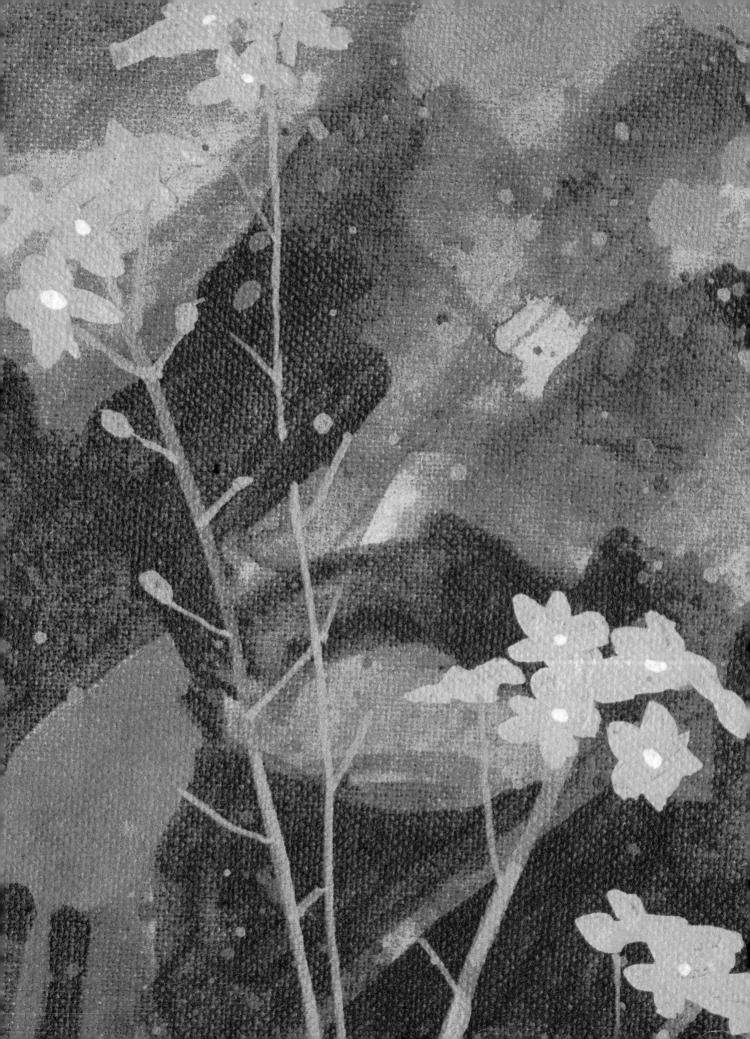

A QUINTET BOOK

Published by Apple Press Ltd. 6 Blundell Street London N7 9BH

Copyright © 1988 Quintet Publishing Limited. All rights reserved. No part of this publication may be reproduced, stored in a retrieval system or transmitted in any form or by any means, electronic, mechanical, photocopying, recording or otherwise, without the permission of the copyright holder.

ISBN 1-85076-114-0

This book was designed and produced by QUINTET PUBLISHING LIMITED 6 Blundell Street London N7 9BH

Art Director: Peter Bridgewater Designer: Ian Hunt Editors: Angela Gair, Fanny Campbell Photographer: Ian Howes

Typeset in Great Britain by
Central Southern Typesetters, Eastbourne
Manufactured in Hong Kong by
Regent Publishing Services Limited
Printed in Hong Kong.by
Leefung-Asco Printers Limited

CONTENTS

INTRODUCTION	(
1 ACRYLIC PAINT	12
2 MATERIALS AND EQUIPMENT	22
3 PAINTING WITH ACRYLICS	34
4 THE PROJECTS	52
5 DESIGNING WITH ACRYLICS	104
EPILOGUE	112
GLOSSARY	124
INDEX	126

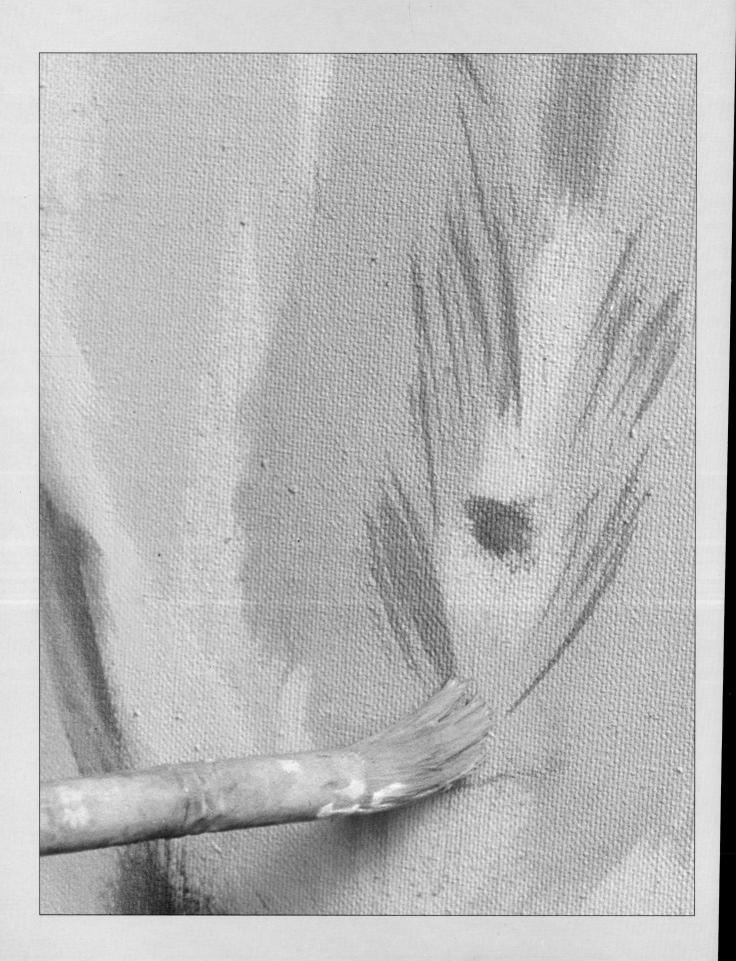

INTRODUCTION

WHY ACRYLICS?

CRYLIC IS a relatively new paint for artists, the first for nearly 300 years. During that time, painters and designers have used mainly oil, watercolour and tempera. In acrylic, we have a modern paint of enormous value to both artists and designers, whatever fields they are in — painting, illustration, graphic design, textiles, jewellery, mural and interior design, even sculpture.

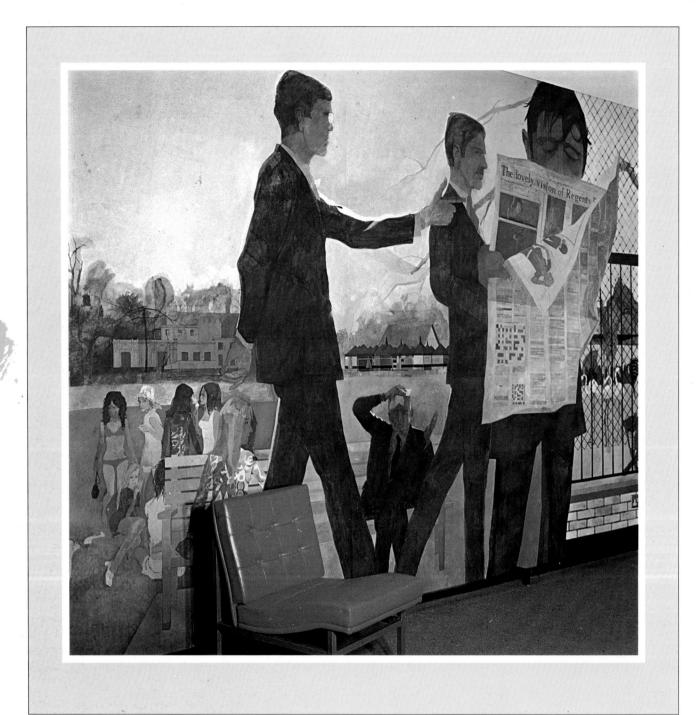

ABOVE Detail of a mural in the Graduate School of Business Studies, London, by Leonard Rosoman.

THE NATURE OF PAINT

THE QUALITIES OF ACRYLIC are exceptional. It is certainly more versatile than most other paints. For one thing, it can stimulate almost exactly what they can do, in many instances better. It is clean to handle and has only a slight, pleasant aroma. No cumbersome equipment is needed, no special chemical knowledge to make it function satisfactorily. This alone makes it ideal for those who find oil paint somewhat messy, its smell unpleasant, its use arduous and something of a performance.

RIGHT ABOVE Terence Millington, Sofa.

RIGHT Leonard Rosoman, Girl Lying in a Hammock.

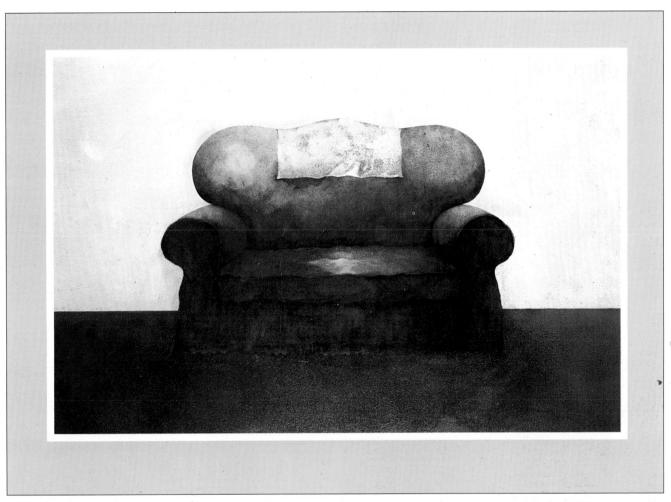

ADVANTAGES OF ACRYLIC

ONE OF THE ADVANTAGES of acrylic is its speed of working. It dries rapidly, in minutes if need be, and permanently. Alternatively, drying can be prolonged to suit individual working requirements. Acrylic dries throughout so thorougly, it can be varnished immediately with either a matt (eggshell) or glossy finish.

Another advantage is that acrylic is both tough and flexible.

WHY ACRYLICS?

THEY ARE: SIMPLE AND clean to handle; flexible; water resistant; tough. Acrylics: can simulate other paints; smell good; need little special equipment; dry fast; can be cleaned; can be repaired; adhere permanently. It does not peel, crack or split, and it is water-resistant. The surface of dried acrylic can be gently cleaned should the need arise, and can be repaired easily if damaged.

Perhaps the most advantageous characteristics of acrylic are its adhesive qualities. It can be applied, without difficulty, to almost anything, and remain, permanently, without flaking or rubbing off. Unlike oil paint, which can damage the surface of certain materials if applied without

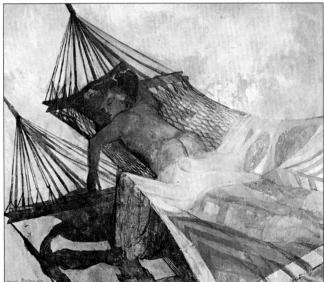

the appropriate priming, acrylic can be used without any special preparation if the situation demands.

Among other things, it will adhere satisfactorily to all kinds of wall surfaces, cloth, paper, card (cardboard), hardboard, wood, plastic – almost any object or surface suitable for painting or decoration.

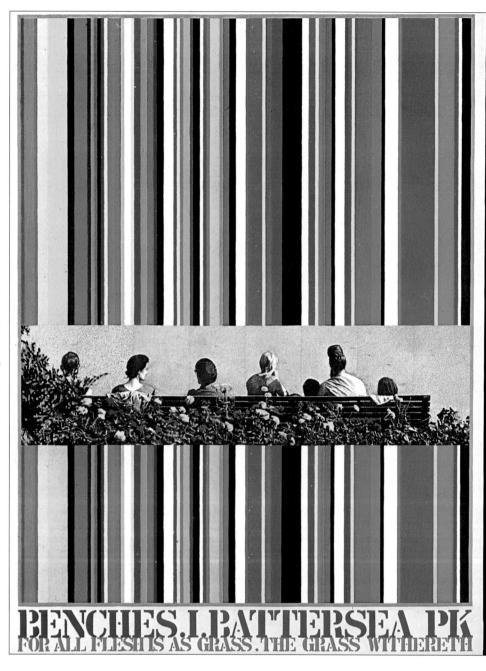

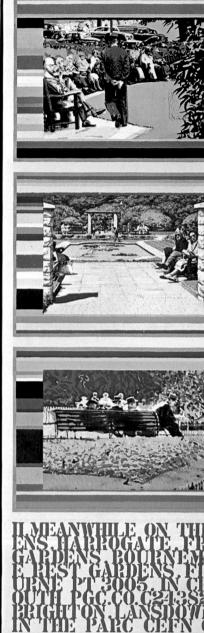

Acrylic is a multipurpose paint; it can be used as a paste as well as a liquid, enabling a variety of surface changes to be carried out and explored. From the perfectly flat, or evenly gradated kind, to the highly modelled, textured surface that has sand, glass, wool fibre and tissue paper added to it. For among its many accomplishments, the acrylic medium is also a powerful glue.

It will especially suit those who delight in bold, bright, clear colours. Conversely it can be reduced to subtle tones and carefully gradated tints by the usual methods of mixing.

Acrylic's simplicity of handling is a major advantage, especially for beginners. The simple equipment needed

ABOVE Tom Phillips, Benches. This painting is based around a series of postcards. The artist has used a number of techniques (eg stippling and hatching) and a wide range of colours.

RIGHT The most convenient way to buy acrylics is in tubes.

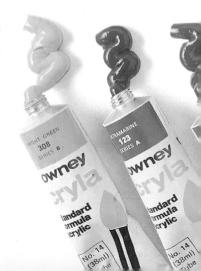

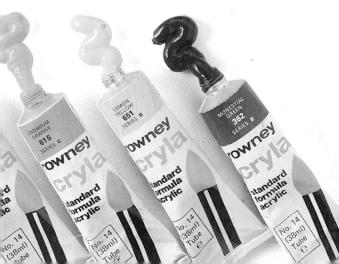

means less initial expense, a further encouragement to those who have never painted before.

Acrylic is uncomplicated to use, but it is important to learn how it behaves. Practice and experiment will teach you how to exploit the qualities of the paint. Experience with other mediums is not necessary; beginners are at no disadvantage to the more experienced painter in understanding acrylics, and the beginner may be less prejudiced and more adventurous than the painter skilled in other mediums. If you begin with a spirit of inquiry, you will soon grasp the potential of this exciting medium. Keep an open mind and persevere, and the results you will achieve will be rewarding.

CHAPTER ONE

ACRYLIC PAINT

CRYLIC PAINT is made by mixing powdered pigment with acrylic adhesive. The adhesive looks milky when wet but becomes transparent when dry, revealing the true colour of the pigment. All the ingredients are carefully weighed and tested before use. It is this painstaking precision and control during the manufacture which enables thousands of tubes of paint of almost identical colour, consistency and quality to be turned out at any time.

THE NATURE OF PAINT

ACRYLIC IS UNLIKE ANY other paint, but it has affinities with all of them, since all paints contain the same ingredient: pigment. A pigment used in water-colour is identical to that used in oil and acrylic. The quality is equally high, its brightness and durability the same, and the care used in manufacture just as thorough.

The major difference between one paint and another is not the colour but something much more fundamental: the binder. The binder largely decides the character and behaviour of the various paints. Binders also play a large part in permanence and drying qualities, brilliance and speed of working. They also determine what kinds of diluents (also known as solvents) and varnishes may be used in conjunction with them. For instance, water is the diluent for watercolours and gouache, and turpentine for oil, because of the liquid binders used.

A brief look into the history and development of paint will provide valuable insight into what may be achieved when it is used with imagination.

The history of painting reveals that before the establishment of paint and equipment manufacturers and suppliers most artists made their own materials. They ground their own paint, prepared their own supports and primings, even made their own brushes.

In studios in the 15th century the apprentices who worked under the master ground the colours and made the supports. It was all part of the artist's training.

Irksome as it may appear to us today, for them it was a normal part of the process of painting to know how paints were made as well as how to use them. It gave them, in effect, an enormous respect for their materials and was instrumental in achieving a high level of craft which, in turn, richly enhanced the creativity of their work.

Today, happily, we can buy brushes and paint of a consistently high standard whenever we need them. And

though we can buy every kind of support to suit all mediums, prepared for oil, tempera or acrylic – canvas, hardboard, card (cardboard), even paper for oil paint – we can, if we prefer, make our own with ready-to-be-assembled stretchers and prepare our own canvas or board with ready-made primings – not necessarily to save money, which it undoubtedly does, but for the satisfaction it will give.

PIGMENTS

PIGMENTS ARE the colouring materials of paint, and are usually made in the form of powders. From the earliest, pigments had to be bright and clear, and able to withstand prolonged exposure to light. Certain colours were apt to fade and did not produce the subtle tints and shades we would admire today, but were more likely to produce a dead or muddy effect.

Throughout history, bright colour was preferred for both practical and aesthetic reasons, having close associations with joy, celebration, pleasure and delight. To express these emotions, bright, rich hues were in constant demand, and the search for pigments that possessed these qualities has been constant over the centuries.

By the Middle Ages the range of colours was quite extensive, and put to complicated use on walls, illuminations, panels, in books and on woodwork. An all-purpose paint like acrylic would have suited them admirably.

After the Renaissance, pigments reached a peak of brightness and variety. Thereafter a more expressive and realistic style emerged and the medium more suited to this was oil paint. Realistic paintings moved away from bright colours to rich, sombre hues, which brought a new range of pigments into being. An interest in brighter colour returned again in the 19th century due, in part, to Constable and Turner, the designs of William Morris, and the Impressionists.

HOW ACRYLIC PAINT IS MADE

1 The first constituent is the powdered pigment.

2 The pigment is mixed with acrylic adhesive.

3 The paint is then milled between steel rollers.

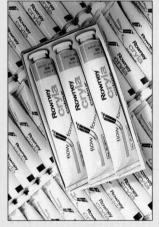

4 After it has been inspected, the paint is put into tubes.

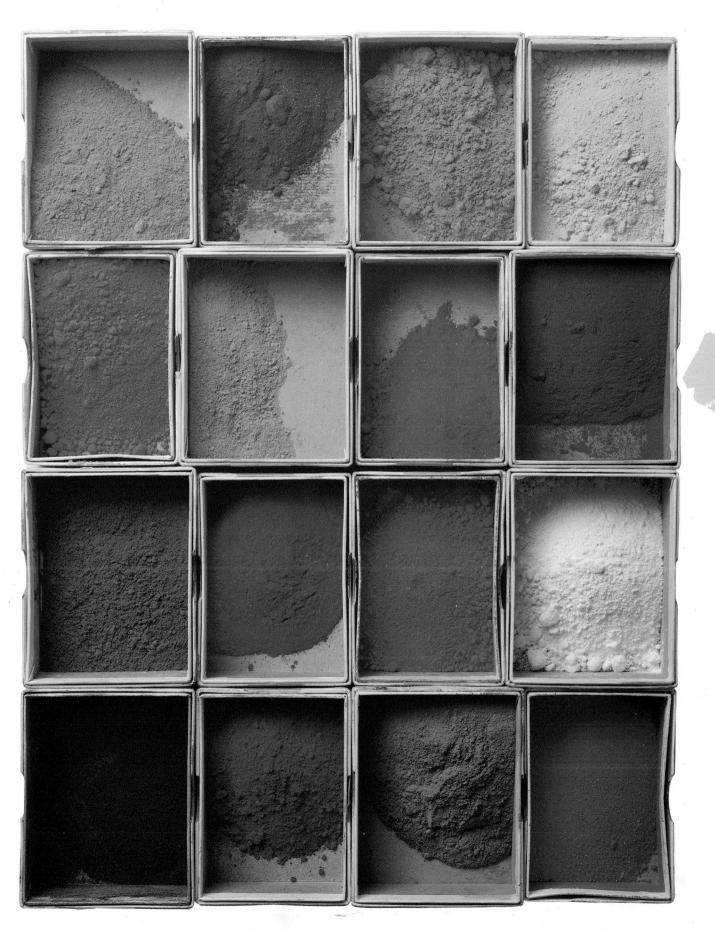

Delight in bright colour today means a wide range of pigments, and the list of those available is long. The names of pigments often echo places: burnt Sienna, Venetian red, Naples yellow, Prussian blue, Chinese vermilion; or recall the materials they are derived from: cobalt blue, rose madder, emerald green, ivory black, sap green, geranium lake and so on. Though interesting sounding, the names give little indication of the quality or behaviour of colours, and some are sold under two or three different names.

To simplify the situation, the names of absolutely necessary colours are listed further on, and you may want to look at a colour chart to see the full range. The number of colours needed to produce a variety of tones and tints need not be large. Pigments today are bright, durable (unless specified) and capable of a great deal of mixing.

Briefly the requirements for a reliable pigment are that: it should be a smooth, finely divided powder; insoluble in the medium in which it is used; able to withstand the action of light without changing colour under normal exposure; and it should be chemically inert and unaffected by materials with which it is mixed, or by the atmosphere. Moreover, it should possess the proper degree of opacity or transparency to suit the purpose for which it is intended, and should conform to accepted standards of colour and colour quality.

The raw materials used to provide the pigments are customarily classified as inorganic or organic. Inorganic materials are those of purely mineral origin such as the natural earths: ochres, raw umber, which can be calcined like burnt umber and burnt sienna, and the artificially prepared colours like cadmium yellow and zinc oxide, the basis of the famous 'Chinese white' which was introduced in 1837 by Winsor & Newton.

Organic pigments include animal and vegetable substances, as well as complex synthetic substances. Vegetable sources furnished colour like gamboge, indigo (now not available) and madder. Animal sources produced cochineal which was made into carmine, and Indian yellow was an incredible colour made in India from the urine of cows fed on mango leaves. It has now been replaced by synthetically made colours. Other artificially prepared organic colours include alizarin, or anilines (now largely discontinued for aritists' colours, but occasionally used as constituents of household paints and printers' inks).

THICKENER

MATT MEDIUM

MODELLING PASTE

GEL MEDIUM

TEXTURE PASTE

Many of these organic colours are no longer produced, and have been replaced by newer and more durable colours that have been developed successfully over the years. Notable among these is the phthalocyanine range, the first of which was a very intense blue, known under the trade name of Monastral blue and a very suitable replacement for the less reliable Prussian blues, whose colour effects and pigment properties it closely resembles.

The range has now increased to include yellows, reds and greens, and a splendid violet, all of them available in oil, watercolour and acrylic. These colours are classed as organic and are derived by a chemical process from an organic dyestuff. They are very intense with a high degree of durability and, like acrylic paint itself, are a modern and flexible addition to the artist's means of expression.

PAINTING WITH PIGMENTS

when pigments are seen as powders they are fresh and bright with a beauty all their own. When mixed with a small quantity of water a paste is formed that can be painted with. When the water dries the bloom returns, but so does the powder. In other words it reverts to its former state. What is needed is something to bind the coloured grains together to make them adhere. For this purpose some kind of glue or binder must be added to the powder before it becomes paint.

The paints that have the slightest amount of binder, so that the pigment is as pure as possible, are pastels. They are, in effect, dry paint, but though beautiful to look at and work with, they are very fragile. The finished work is easily brushed off unless properly fixed, which, of course, takes away some of the original freshness, and represents the major difficulty over the centuries: to bind the paint so that the colour is not impaired.

To repeat, the major difference between one paint and another is not the colour or the pigment, it is the binder. Understand the nature of binders and you are half-way to understanding acrylic. This is where the mystery lies.

BINDERS

■ GUM

The earliest form of binder was a gum, probably gum arabic, though gum tragacanth was supposedly used by the Egyptians. Gum tragacanth is used principally to bind pastels, and gum arabic to bind water colours and gouache.

The popularity of gum arabic as a binder is probably because it dilutes well with water and does not impair the brightness of the pigments. It can also be made into small cakes of paint that are compact and easily stored, and dissolve easily when needed. The only limitation is that watercolour has little body, and is best used transparently, in washes and glazes.

As soon as white is added to the pigment it becomes more opaque. This kind of paint is known as gouache (derived from the Italian word for gum) and dries matt and bright. It is very popular with designers and often referred to as designer's gouache or poster colour.

Gouache can also be bought in cake form, but is more practical in liquid form, in bottles and tubes. It is not waterproof and cannot be overpainted without picking up the colour underneath. Neither will it stand up to harsh treatment or exposure. Like watercolour, the only protection is to put it immediately under glass.

■ EMULSIONS

Any sort of paint that is bound with an emulsion that contains oil, but is mixable with water, is called tempera. The tempera most frequently used throughout the Renaissance contained the yolk of an egg. Other emulsions contained casein glue, wax and parchment size. The oil most often added to the emulsion was linseed oil.

Most of the paintings and decorations of that period, seen in museums and art galleries today, could be correctly assumed to be tempera paintings.

Egg tempera in particular, dries quickly, hardly changes colour, and is fairly waterproof – sufficiently so not to pick up when over-painted. It has a good surface that wears well, provided it is treated with care. It is by far the best of the mediums, but requires technical knowledge and expertise to handle it well.

There are other drawbacks: speed of working is slow, it does not cover large areas well and is therefore better confined to small panels. There is always the difficulty of making flat, even coats of colour on a large scale because the emulsion binder cannot accommodate huge amounts of pigment – something acrylic can do with ease.

Tempera lends itself to simple, images. For more realistic forms of expression, oil paint is more suitable.

OIL

The most common oil used to bind pigment is linseed, and gave the freest possible manner of working for over 300 years. In fact until the introduction of acrylic, an artist could work on a large scale with oil paint without the limitations imposed by tempera and fresco (a pure, but temperamental binder that only functioned well in hot, dry climates) and paint as realistically – or expressively – as vision dictated.

Pigment ground with oil is slow to dry and therefore slow to use, but it brought a softer, more delicate tonality to painting, and did justice to the visual delights of light and shade. Moreover, because of its consistency, it could exploit more surface textures than tempera.

Drying could be speeded up with the addition of siccatives, like copal, dammar and mastic, which in turn could also be used as varnishes. The addition of natural resin toughened the paint so successfully that all manner of objects and surfaces could be painted.

The practical application of oil paint outweighed its many disadvantages: that it darkens over a period of time, attracts dirt, is difficult to clean, cracks and peels, and is messy and smelly.

Oil paint has to be diluted with turpentine and brushes and palettes cleaned with white spirit and can be applied only to primed surfaces. It requires technical expertise and virtuosity and is not an easy medium to master.

ACRYLIC BINDERS, MEDIUMS, VARNISHES, RETARDERS AND SOLVENTS

THE LIQUID binders mainly used for oil paint, watercolour, gouache, tempera, fresco, wax encaustic and so on, were not intended specifically to bind pigments. Linseed oil, egg, gum, wax and lime are natural products with many other uses, and were adapted to make paint. Consequently all kinds of difficulties were apt to crop up to spoil or limit the full potential of the paint.

Acrylic binders are completely different. They are made specifically for the jobs intended for them. Chemically, acrylic binders are based on polymer resin, and classed as an emulsion into which pigments are mixed. It is, in short, a clear plastic, with great adhesive properties, and water-resistant – despite the fact that the diluent is water. For once the binder is dry, it becomes completely insoluble in water.

Acrylic binders (or more specifically, mediums) can be obtained in three consistencies. This alone makes acrylic unique. With oil paint, a number of alien products are needed to thin or thicken it. Acrylic thinners and thickeners belong to the same family. With them, not only are we able to achieve what other paints can, but a great deal more besides. These mediums, or binders, come as:

- liquid
- jelly (Gel)

- paste

They are milky-white in colour when wet, but after evaporation of water, they dry to a clear, transparent film, which is fairly tough and flexible. This also ensures maximum brightness of the pigment.

When these binders are used to exploit the possibilities of acrylic paint they become in effect mediums: liquid constituents of paint, in which the pigment is suspended, or liquids with which the paint may be diluted, without decreasing its adhesive, binding, or film-forming properties.

Mediums can loosely be described as paint additions to make the paint flow or dry more variously, or to produce different results for special kinds of work (impastos, for example, where the addition of a medium will give more bulk to the paint), or, as in the case of acrylic, to transform it into a modelling material. These additions can also thin or thicken to produce a variety of visual effects such as glazes, scumbles, impastos, etc.

Although you need not try them all immediately, you may want to know something about them and what they are capable of, to understand the possibilities of acrylic, and to experiment with them later.

ACRYLIC GLOSS MEDIUM

Acrylic gloss medium increases the translucency and gloss of acrylic colours while reducing consistency to produce thin, smooth paint layers which dry rapidly. This means that an unlimited number of glazes of exceptional brilliance, depth and clarity can be developed and exploited.

A few drops of the medium mixed with ordinary watercolour or gouache immediately transforms them into an

acrylic paint, that is, they take on many of the characteristics of acrylic paint: quick-drying, water-resistant, capable of overpainting without picking up and a gloss finish.

The acrylic gloss medium is an essential part of the acrylic artist's paintbox, as essential as water itself, for nearly all the main tasks that acrylic is capable of are much better done with a few drops of the medium added to the paint or wash. This medium has a secondary function as a gloss varnish though there is a newer and more practical and versatile product in two finishes, gloss or matt, which can between them furnish a glossy, semi-matt or eggshell, or matt finish.

■ ACRYLIC MATT MEDIUM

The matt medium behaves in a similar way to the gloss, and everything said of the gloss medium also applies to the matt. It is a useful medium to have if you intend to paint matt, so that the tones of the colours can be properly mixed before painting. There is an appreciable difference in tonality between matt and glossy finishes. The pigment dispersed in either medium may be the same for both matt or gloss, but the light affects them differently. To allow for this during painting, the addition of a few drops of matt (or gloss) medium in the paint mixtures will ensure that, on drying, you get exactly the tone or tint you want.

■ ACRYLIC GEL MEDIUM

Gel medium is thicker than the gloss or matt mediums. As its name implies, it is jelly-like in texture and consistency, and like the gloss medium has two distinct functions.

First, it enables thick, highly textured impastos to be produced easily while maintaining consistency of colour, and second, the colours increase in translucency the greater the proportion of gel medium used. At the same time, the drying rate is retarded to some degree.

Glazes and impastos are an integral feature of acrylic painting and, because of its fairly quick drying qualities, acrylic has an advantage over oil paint, which is by comparison a slow drier, making glazing a long drawn out operation, in which it is hard to foresee the result.

Glazes are made by laying a transparent film of colour over another that has already dried. With oil it may take up to two months for a surface to dry out thoroughly for glazing to be done. With gel medium it can be done in a matter of minutes. Moreover any number of glazes can be overlaid, and not just one, as with oil paint. Glazing is a beautiful way of using colour so that its brightness and purity is exploited to the full.

Both the acrylic gloss medium and gel medium can be used to make glazes. The difference is merely one of consistency. The gel medium is much thicker than the gloss, and therefore can also be used for impastos. Nevertheless it will make beautiful glazes especially with a palette knife.

Impasto is thick paint that can be textured by the movement of the brush or by the edge of the palette or painting knife.

Impasto has been a particular characteristic of oil paint, and gives tremendous vitality to the expressiveness of the image. Gel medium can achieve this effect in exactly the same way as oil paint, with just as much vitality, and is less

liable to crack. It dries much quicker than oil so is less easily spoiled or damaged during painting and, once dried, it becomes very hard to dislodge.

■ ACRYLIC TEXTURE PASTE

The thickest, and the most powerful acrylic binder, comes in a carton. Though more dense than the other two binders, it can be watered down without any loss to its adhesive powers.

It can be used to make those very heavy impastos that Vincent Van Gogh was so fond of; for this kind of vigorous brushstroke, large brushes will be needed, or a palette or painting knife will serve just as well.

Alternatively, instead of using this medium to make thick coloured impastos, it can be formed so that other materials, for example sawdust aggregate, may be pressed or embedded into it, to create richly textured surfaces.

Grumbacher, Winsor and Newton, and Rowney Cryla (2) are just a few of the acrylic paints on sale today Rowney Flow Formula (1) is used for covering large areas with flat colour. The canvas should be primed with an acrylic primer (3) or gesso (4). Mediums are available in gloss (5, 7, 11, 13) or matt (6, 10) textures. Retarding medium (16) slows the drying time of the paint. Like mediums, varnishes can be matt (8, 9) or gloss. Acrylic varnishes are normally insoluble, but Rowney make a soluble gloss variety (12). Also useful are gel medium (15) and water tension breaker (14).

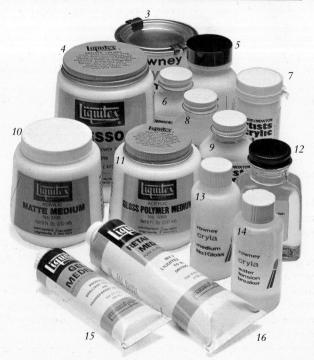

The Tepline paste medium has remarkable adhesive powers, and so presents numerous possibilities for design, one of which is the pleasant and simple assemblage known as collage. It presents many possibilities for design and can be used to model and, with the addition of sand, marble dust or other aggregate to strengthen it, it can be carved or cut and even sanded when dry.

■ ACRYLIC WATER TENSION BREAKER

The water tension breaker is a concentrated solution of a wetting agent, which is diluted with water before use. Water tension breaker can be added to water, or matt or gloss mediums, following manufacturers' instructions in quantities depending on the effect required.

Use of this additive allows easier, more rapid thinning of colours with minimum loss of colour strength. Staining effects of maximum intensity into difficult surfaces, such as unprimed canvas, are more easily attainable with colour diluted in this way.

The flow and ease with which the colour may be used are increased so that flat, even washes of colour can be applied to large areas of the work. This is ideal for hardedge techniques, and for spraying acrylic colours.

It should also be very helpful for those who like to use acrylic in free-flowing washes (like watercolour for example). All that would be required is a few drops of the tension breaker in the container of water.

■ ACRYLIC GLOSS VARNISH

The main advantages of this varnish are that

it is not prone to bubble formation (as the acrylic gloss medium tended to do if brushed vigorously).

it is removable by an acrylic varnish remover (the gloss medium cannot be removed, as it becomes an integral part of the painting when used as a varnish).

★ it has a remarkably good flow, which means that it will spread evenly over the surface, without leaving unsightly brushmarks.

This gloss varnish is water-based and dries to a flexible, transparent, extremely light-fast, glossy film. Two coats applied liberally are recommended since any parts that may be missed by the first coat will be covered by the second. On the other hand, the application of two coats necessitates waiting for at least two hours for the first coat of varnish to dry before the second can be applied.

Some manufacturers recommend slight dilution with a few drops of water to achieve good flow, but I have found that this varnish flows very evenly straight from the bottle. However, a few drops of water never does any acrylic material harm – on the contrary, it acts as a safety device for both paints and mediums to be so diluted.

The final varnish film is water-resistant and scuffresistant and brings out the brilliance of the colours wonderfully. It both protects and enhances at the same time, which is the major reason for varnishing finished work. Varnishing consequently becomes the normal extension to painting, and should offer few problems if all these points are observed.

Acrylic gloss varnish can also be used to varnish prints and posters to protect and enhance them. The varnish

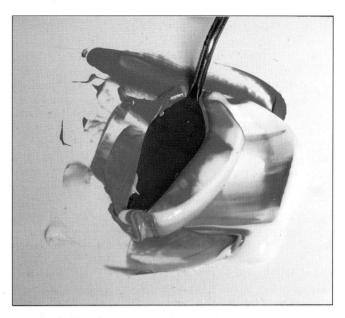

TOP A painting knife is used to mix paint and gel in equal proportions.

ABOVE The consistency of the gel is thick, and so it retains the shape of the knife marks.

should, however, be applied first to a small test area to assess suitability for use. It should also be pointed out that attempting to remove varnish film from prints is not recommended, as damage to the print may result.

Should cleaning of the varnish film be necessary, a soft cloth moistened with either water or weak soap solution can be used with complete safety to wipe the surface.

ACRYLIC MATT VARNISH

For very large works – murals, wall decorations, exhibition stands and so on – it is usually the practice to varnish with a matt finish, as a glossy surface on a large scale will reflect the light unevenly, giving an unwanted

shine. Irregular shine will distort the image, or impair the visual effect which can be very irritating to look at. The only answer to this is a completely matt surface.

Similarly for those who prefer blonde or high-key colours, a matt finish will be more suitable than a rich glossy one. Be careful when buying the varnish to stipulate exactly the kind of varnish you require, and to check the label on the bottle. Acrylic matt varnish has similar qualities to the gloss varnish. It is also removable. One coat will be found to be adequate, but another may be given if necessary after two hours. It can also be used on prints and posters.

SATIN ON EGGSHELL FINISH

If you find that a glossy finish is too shiny, or a matt one too bland, there is a way of making an intermediate finish. Simply blend the gloss varnish with the matt in a saucer, or container, and brush on as directed. The resultant midway finish can be adjusted to suit individual preferences by adding either more gloss or more matt to the mixture. A prepared satin finish is also available in art supply shops.

TEN SIMPLE RULES FOR SUCCESSFUL VARNISHING

VARNISHING WITH acrylic matt or gloss varnish should present no difficulty provided these ten points are followed.

Varnishing can be carried out with undiluted medium, straight from the bottle, but it is a more practical, and safer, practice to pour a little medium into a clean saucer or container and add a few drops of water to thin it slightly. This slows the drying rate, enabling you to carry out the operation without haste.

Always varnish, if possible, with a soft brush. A hard brush may leave brushmarks, which will look unsightly. Wash brushes immediately after varnishing. Dried varnish is very hard to remove and if left may harm the brush.

To be quite certain of completely covering the surface with varnish, look obliquely along the work. Any untouched areas will be detected immediately because of the reflected light.

Discard any unused varnish and use a fresh supply each time.

Although the varnish has no smell to speak of, there is no reason for leaving the screw-cap off when not in use. The water in the medium will evaporate fairly quickly, and if it does, the varnish will no longer do its job properly.

The surface to be varnished must be absolutely dry – that is, dry all the way through – otherwise the varnish will pick up and spoil the look of the work. Acrylic paint dries fairly rapidly, and it should not prove too difficult to determine whether the paint is fully dry or not. Nevertheless thicker coats of paint, like impastos, may be deceptive. The best rule is to leave it for a week or so to make absolutely certain.

Ensure that the work to be varnished is clean. Specks of dust and other unwanted particles can appear from nowhere, so gently brush the surface with a clean, soft rag or soft brush prior to varnishing.

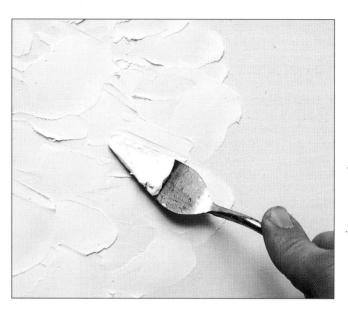

ABOVE Texture paste is the thickest acrylic medium. Here, it is applied directly to the support.

Always varnish in a clear atmosphere. Don't carry out the job, for example, in a room where any sawing, planing or sanding has taken place. Once grit or dust gets into the varnish it is difficult to remove without damage to the paint, and a great deal of time-consuming trouble.

Don't hurry the job; take plenty of time to do it properly. Put aside the work to be varnished until it can be done without haste.

Never under any circumstances use acrylic varnish over oil paint.

Varnishing is a normal part of painting with acrylic, and should offer few problems if these ten points are scrupulously observed. If in doubt, the best procedure is to try the varnishing exercise with the medium on any and every kind of expendable surface available. Paintings that have been discarded make a useful beginning; or splash some acrylic paint on a piece of card or paper, and experiment by varnishing them when dry. It should not take long to grasp the principle of varnishing with a soft brush.

If for some reason either of these two varnishes is to be removed before revarnishing, this varnish remover will do it successfully. The remover should be applied liberally to a soft cotton pad and then rubbed on to the varnish film. The varnish will begin to be removed almost immediately, and care must be taken to avoid excessive rubbing of the underlying acrylic paint. Any slight paint pick-up on the pad will indicate that complete removal of the varnish has taken place. Revarnishing can then begin.

■ SOLVENT FOR DRIED ACRYLIC COLOURS

There are always occasions when dried acrylic paint gets where it is not wanted: on brushes particularly, and on palettes and clothing. It is amazing what hot water can do to dried acrylic, by allowing it to float off certain kinds of surfaces such as china, glass or stainless steel. With more

porous or absorbent material, however, dried acrylic paint is much more stubborn and difficult to remove.

This solvent therefore is a useful material to have when that kind of emergency arises. It should only be used in a well-ventilated room. Avoid breathing too much of the vapour, and refrain from smoking when using it.

The solvent softens the paint so that it can be removed easily. It can be used on brushes, palettes, clothing and paintings with perfect safety, provided the above conditions are observed.

■ RETARDERS

Retarders are available in both liquid and gel form. One retarder I used, which is slightly translucent and gel-like in consistency, retards the rate of drying considerably when blended with acrylic colours. Even on a very warm day, the colours I mixed with it remained wet for hours.

Gel-like retarders have the advantage of allowing textural effects and impastos to be achieved. Fluidity can be attained by adding a little water. However, mixing must be carried out thoroughly with a knife, the proportions being three times the amount of colour to one of retarder, and six times the amount of colour to one of the retarder for the earth colours (yellow ochre, raw sienna, light red, burnt sienna, burnt umber, and raw umber.)

Retarders are effective only if used with thick paint; water limits their performance, so you have to choose to some extent between diluting your paint and using a retarder.

No firm drying times are given, but it seems to stay moist for a considerable length of time, sufficient to do any amount of work required before drying.

OIL ON ACRYLIC

As a general rule, one may take it as axiomatic that oil and

acrylic don't mix, except in one particular instance: oil paint may be painted over acrylic paint, preferably on a rigid support, like hardboard. Canvas is not recommended.

But acrylic must never be painted over oil. Oil rejects acrylic, and moreover dries in an entirely different way from acrylic, so the result will be little short of disastrous.

However, because oil can be overpainted on to acrylic, it means that one can paint backgrounds or underpaintings with acrylic before finishing with oil. This is somewhat like the methods adopted by the old masters of underpainting with tempera, because it dried quickly, and finishing with heavier, slow-drying oil, which had more texture and body, and which, because of its slower drying time, was capable of considerably more finish and fine detail.

Whether the method of overpainting acrylic with oil is preferable to painting throughout with acrylic, using a retarder for the parts of the work which need a slower drying rate, is open to conjecture. The answer can only be arrived at by personal experience, and a degree of experiment.

Paint is prepared on a palette or in a container before it is applied to a surface. If the paint is too thick, it can be thinned or diluted with a solvent, or diluent. If too thin, mediums can be added to give more body. If the paint dries too quickly, a retarder can be added to slow the rate down. The aim of these additions is to ensure that the paint will flow properly from the brush or knife. If it flows evenly there will be no strain or pressure needed.

Tools and equipment play a great part in painting, and must be properly looked after to perform their functions well.

Acrylic paints can be used very effectively in combination with oil crayons.

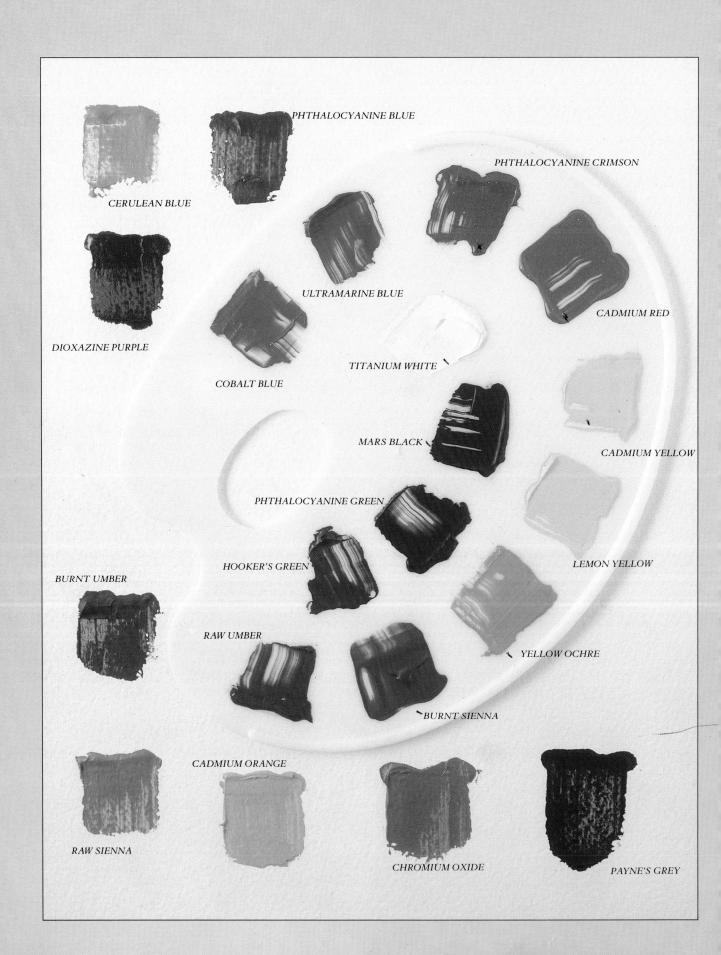

CHAPTER TWO

MATERIALS AND EQUIPMENT

AINTING CONSISTS OF a number of specific actions, for example smearing, brushing, dabbing, swirling, tinting, staining, spraying, sponging, spattering and spreading.

The tools needed for this job are usually brushes of varying types and sizes, knives known as painting or palette knives, sponges, airbrushes and rollers.

For best use of materials:

- Mix paint well.
- Mix sufficient quantities.
- Apply generously.
- Keep equipment and tools clean.
- Don't hurry the process.
- Be gentle, let the tools do the work.

The tools and equipment needed for acrylic painting are exactly the same as for oil painting, watercolour and gouache, with a few minor differences.

WATER CONTAINERS

WATER IS THE ONLY SOLVENT, or diluent, needed for acrylic painting, because acrylic paints are water-based. But whether the paint is to be diluted or not, plenty of clean water is essential for keeping brushes clean, and to prevent paint drying on them. You will want glass, china or plastic containers – jars, cups, bowls, glasses – for this job.

Brushes and palettes will dirty the water as you clean them, and will leave a deposit of sludge after a time. This will sully fresh paint and fail to clean brushes properly. So have as many containers as possible, change the water in them frequently and, if they are disposable, throw them away when they become stained.

Jam, peanut butter, instant coffee and similar jars are also useful for keeping brushes in.

Two containers are not recommended: narrow-necked bottles which restrict movement, and any kind of tin can or container as they are liable to rust and will ruin paint and brushes if they do.

Have at least two large containers available, filled with clean water, one for diluting paint and the other for cleaning brushes. You will also need clean water to keep the paint on the palette moist. Acrylic paint dries when the water in it evaporates, and is then difficult to dislodge. To prevent this, splash a few drops of water on the paint with a brush from time to time, or use a small hand spray.

Wash out dirty water containers regularly. Dirty water will stain them if left overnight, and they will then be difficult to clean.

- holds paint well on the surface
- is easy to keep clean
- has a smooth non-porous surface
- is white in colour
- has a lip or edge

Choose a palette that is:

- large enough
- practical for your purposes
- suits your style of working

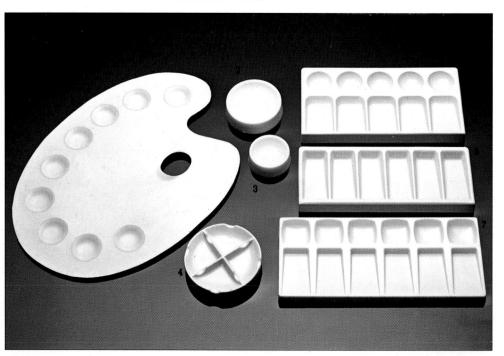

LEFT There are many forms of palette. (1) The traditional palette with thumb hole may be held in one hand while painting. (2,3) Small pots may be used to mix colours separately. (4,5,6,7,) Alternatively, you may wish to keep the colours together in a larger palette with several wells. The paiette used is a matter for the artist's personal choice.

PALETTES

THE NEXT IMPORTANT PIECE of equipment is a palette.

The nearest object I have found to fulfil all the conditions for the ideal palette is a large china plate.

A porcelain or glazed pottery surface is easy to keep clean. If paint dries on it, it can be cleaned with hot water. A few minutes soaking is all that is needed. For more stubborn cases, soak for a longer time in hot water; paint should then scrape off quite easily.

A white plate is an advantage. White allows mixtures to be accurately gauged; a coloured surface plays optical tricks and is best avoided.

The lip or edge on a plate is only important if the mixtures are rather liquid. For stiffer mixtures, using thicker paints, a pad of paper palettes has advantages. Mixing is done on the top layer, which can be torn off and discarded. Paper palettes are not very practical for more liquid paint, or washes, as the paper tends to wrinkle and the paint to spill over the edges.

Another possible palette is a sheet of plain white plastic. The advantage here is that it can be bought in any size. Most palettes tend to be small, useful for taking outdoors for sketching trips, but not nearly large enough for working in the studio.

A sheet of firm, white plastic, glued to an old kitchen table, will make not only a good surface for mixing paint on, but can double up as a working desk.

If there is any disadvantage in a plastic palette it might be in the way acrylic paint clings to it. Some kinds of plastic also have a tendency to stain, unless kept scrupulously clean. Plastic palettes can be obtained at most art supply shops.

CHOOSING A PALETTE

THE CHOICE of palette will depend, broadly speaking, on how you paint – large or small, with thick paint or thin paint or washes.

For thick paint you will want plenty of room for mixing and holding the amount to be used. For thin paint and washes a lip or edge to the palette is mandatory, or the paint will spill. For washes, china saucers are very satisfactory and, being small, are easy to keep clean. They will stack neatly and so will not take up too much room on the painting table.

Choosing a palette will entail a certain amount of trial and error in the early stages, but from my personal experience one fact stands out sharp and clear: you cannot have too many palettes.

PALETTE SURFACES

MANY SURFACES will do as palettes. A sheet of glass, though a bit slippery, with a sheet of white paper underneath, is possible. Enamelled metal or marble tops will do at a pinch. But the palette to avoid is the traditional wooden kind used for oil painting. It has nearly everything

wrong with it, from its colour to its absorbency. It is difficult to keep clean and is generally impractical for acrylic.

Another surface to avoid is any kind of metal that is uncoated or untreated – with enamel or plastic etc. Metal is liable to corrode, and if it does, will contaminate the paint. Also avoid old or dirty surfaces, or spongy surfaces like leather or rubber.

As a last resort, a piece of ordinary hardboard, or thick cardboard, primed with white emulsion – as for supports – will serve. If it should stain, after cleaning give it another coat of emulsion, and it will be ready for use next time. Such a surface is a little more porous as a palette than plastic or china, but with successive coats of paint it will become less so.

One kind of palette that can be carried in the hand is made of hardboard and coated with a thin sheet of plastic on both sides. It is very light and can be held easily by placing the thumb through the hole specially made for this purpose.

When painting with acrylic, it is more likely that mixing will be done on the painting table, in container-like palettes, rather than on the flat.

The answer is to try them all, if possible, as and when the need arises.

MIXING

AFTER PALETTES COME THE mixing implements, which can be either brushes – the most common – or palette knives – the most practical.

Like brushes, palette knives have more than one function. Both are used to mix and apply paint; the palette knife is also used to clean palettes, which makes it, on balance, a necessary piece of equipment. But this is not all. Whereas brushes may apply paint more satisfactorily, the palette knife mixes paint better. For clean, well integrated mixes, the knife remains supreme. The flat, smooth, firm metal shape is perfectly adapted for large and small mixtures. Moreover, the freshness of the colours is better preserved, because they and the mediums used will be properly amalgamated. Tones and subtle tints will then be more easily assessed as to suitability, and texture is retained.

PALETTE KNIVES

THE PALETTE KNIFE WILL not only clean the palette, but is itself easily kept clean. A rub of a rag is all that is needed. Dried-on paint can be scraped off with a knife or razor blade, after softening, if necessary, with warm water or a solvent.

Scraping won't damage a palette knife, as it would a brush. A palette knife is almost indestructable, and with reasonable care should last indefinitely. (I have had a number of palette knives for well over 20 years.) A brush, by contrast, wears badly if used for all kinds of mixing – other than small amounts on the palette – and should be regarded primarily as a painting tool.

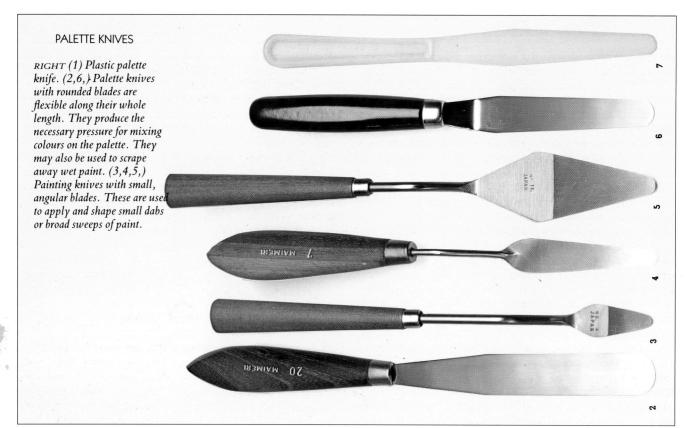

For mixing (and cleaning) paint, the palette knife is a vital and necessary part of any paintbox, and you can also paint with it. For those who find brushes awkward or difficult to manage, the palette knife will provide the answer. Clean, well-mixed paint can be applied to the support with broad, vigorous strokes. For finer work, specially fashioned knives, (known as painting knives) make a variety of delicate marks that are very effective. Of coarse, for more intricate painting and finish, brushes are the superior tools, but for certain kinds of effects, the painting knife can be extremely successful.

Knives, whether for palette or for painting, consist of a wooden handle, and a metal (or plastic) blade. They may be straight, or cranked. The straight are continuous, from the wooden handle to the blade which must be of either stainless steel or plastic. The cranked have a bend that enables them to be manipulated more easily for both mixing, painting and cleaning.

Broad-faced knives, like putty knives and printers' mixing knives, tend to be too large and clumsy for acrylic mixing and painting. On balance, the most suitable is a cranked knife that is not too small or too flexible, that will clean, mix and apply paint equally well. The aim should be to use both palette knife and brush, switching from one to the other as and when the situation demands.

BRUSHES

BRUSHES FOR ACRYLIC PAINTING can also be used for oil painting. The range is identical.

BELOW Brushes are made in several different materials, both natural and synthetic. These are from left to right: red sable

round, Russian sable bright, red sable bright, red sable fan blender.

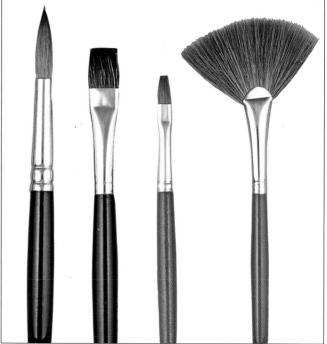

SABLE BRUSHES are delightful to work with in all mediums; they can be used for watercolour, oil and acrylic with equal success. Having specially fashioned points, they can make the most delicate lines and strokes. In addition, they are constructed to hold the paint well, and so spread it with ease and fluency.

The advantage of a sable brush over most of the others is that it responds so sensitively to the touch, allowing the most gentle of marks to the broadest of washes to occur with the slightest pressure of the hand. Your intentions are carried out immediately with a sable, which in effect becomes an extension of the hand.

They are also expensive, and so must be carefully treated on all counts. If sables are used with acrylic paint, they must be scrupulously washed of all colour after use. Acrylic dries hard very quickly, so always keep water handy, to ensure that there is little chance of that happening. Get into the habit of dipping your brush into the water when not in use.

The range and the variety of sable brushes may appear bewildering initially, but a good start can be made by narrowing the choice down to two: a number 3 for fine work, and a number 7 for broad, both round in shape. Other sizes can be added later.

To these can be added ox-hair or squirrel brushes which, though a great deal less expensive than sable, are very useful to do those jobs that would otherwise be impossible. Large areas, for example, which would need a very expensive sable to do the job, could be done just as satisfactorily with an ox-hair or squirrel brush.

A good all-round selection of brushes must contain a few soft and hard brushes to meet all possible contingencies.

The best hard brushes are hog's-hair.

RIGHT Choice of brushes, as with most other equipment, is a completely personal matter. An artist may wish to use only one type of brush. In this case, he or she will need several different sizes. If the artist wishes to use all types of brushes, three sizes of each may be necessary: small, medium and large.

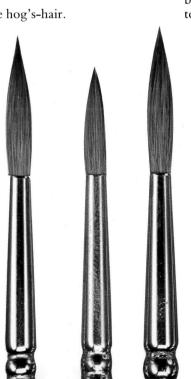

HOG'S-HAIR BRUSHES WERE mainly used for oil paint, until the introduction of acrylic, for which they are admirably suited. They differ from sables in a number of ways: whereas the majority of sables are round in shape, hog's-hairs come in four quite distinct shapes: round, bright (or square), flat and filbert, which are capable of a great variety of marks

Hog's-hair brushes are made from real bristle, and are dressed and shaped according to the natural curve of the hair. They are so skilfully put together that they always retain their shape no matter how much paint is on them and how vigorously they are used. Though sturdier than sables, they must still be treated with care by keeping them clean, and not doing too much mixing with them.

Choosing a selection of these brushes may be done in the same way as with sables: a small and a large from each type – say a 3 or 4 small, and a 7 or 8 large, depending on individual preferences and cost.

Other brushes that may be found to be useful are household and nylon brushes.

Household brushes, the kind that are used for painting woodwork around the house, come in various sizes, and are extremely useful for the kinds of painting that are too arduous or rough for sables and hog's-hair – for example, priming supports, and painting sculpture, models, and other kinds of design, preparatory to painting with sables.

SYNTHETIC BRUSHES

NYLON BRUSHES have improved a great deal since they were first introduced. They are available in a large variety of sizes and shapes, perform well, clean easily and, as sable brushes have become very expensive, are good alternatives to sable and the finer hog's-hair. Synthetic fibres are robust

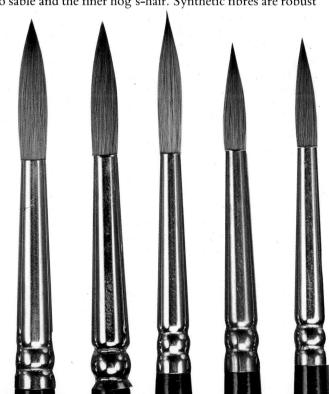

RIGHT Brushes come in many sizes. Most ranges are numbered from 1 (the smallest) to 12. Extra large brushes (numbered up to 36) are also available.

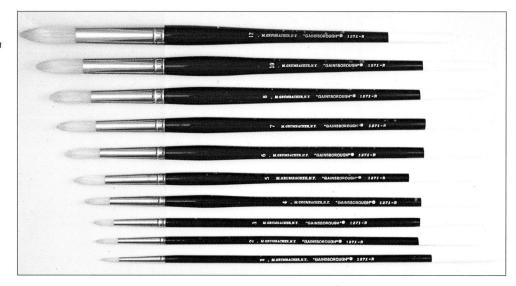

and wear well under vigorous use. They are cheaper than other brushes and well worth trying.

CLEANING AND CARE OF BRUSHES

LOOKING AFTER brushes is part of painting. If treated properly, they will give good service and do their job well.

Washing brushes after use is more thorough an operation than cleaning them during work. It does not mean a swirl round in clean water. Colour has a habit of remaining deeply embedded in the ferrule and must be removed, or it will ruin the brush in time. Therefore make it a practice to wash them with warm water and mild soap (not a detergent). Lather in the palm of the hand, watch all the hidden paint emerge, rinse well in plenty of warm water, shake out the excess, and shape the points before allowing them to dry upright in a jar or bottle.

If brushes are unfortunately encrusted with dried paint, you can try one of these two methods. Soak them in warm water for a few hours. Warm water will soften the paint, and then it may be removed by easing it off carefully, preferably with the fingers. Avoid using any kind of sharp implement, like a knife to do this part of the job. You may damage the hairs irrevocably if you do. Once the point or edge of a brush is damaged, the brush is virtually useless. Or try a solvent.

Acrylic has a tendency to be more coarse in texture than

watercolour or gouache – a good reason to avoid vigorous mixing and application, especially with sables, and, instead, to use a palette knife more often. One way of avoiding vigorous handling is to hold the brush lightly so that it almost falls from the hand, rather than gripping it so tightly the hand becomes tense and so the brush takes the strain, which will in turn show in the brushmarks.

This may seem obvious, but for those unused to the behaviour of brushes, tension may easily be the result of unfamiliarity with them. Brush marking and manipulation exercises and experiments will be of considerable help in overcoming this problem.

SUPPORTS AND SURFACES

ANYTHING UPON which a painting is executed is called a support. Traditionally they were wood panels, walls and canvases; today we also use paper, card (cardboard) and hardboard.

Every painting or painted surface consists of three elements: a support – the material upon which one paints; the ground – which covers the support (also referred to as priming); the paint itself, usually put on in layers.

Supports, ideally, should be light enough to be transported without damage – unless fixed to a wall, or indeed the wall itself. Card and hardboard are light and service-

RIGHT Types of supports (left to right): canvas board, daler board, primed paper, hardboard (smooth side), hardboard (reverse side), plywood.

The Rother The Leave Bother The Law Bother The Law

PRINTED PAPER

CARE OF BRUSHES

- Keep them clean.
- Store them when not in use any box will
- Add a moth repeilent.
- When in use, arrange in a jar, or bottle, heads up splayed out, to avoid damage.
- Don't use the same brush too often; give it a rest occasionally.

able in the smaller sizes, though hardboard is cumbersome in anything over a square yard/square metre.

For large, portable paintings, canvas remains the most convenient. Supports are always treated with a ground to preserve the support and, receive the paint satisfactorily.

Grounds are traditionally white, for the good reason that a white base will not impair the brilliance and permanence of the colours laid on it; and slightly absorbent, to ensure that the paint adheres well. The surface can be roughened or textured to do the same job.

This roughness or texture is usually referred to as the tooth. The natural grain of canvas gives a perfect tooth, and many card or hardboard supports purchased readymade for painting have a simulated canvas grain because it keys the paint so well.

A white base is absolutely necessary for oil painting, as oil paint goes transparent in time, and, if on a dark ground, will darken the colours subsequently. Acrylic colours do not go transparent with age, but even so, a white base is more suitable for painting on. Grounds and primings are really no more than coats of paint, and are often referred to as the undercoat or underpainting by painters and decorators.

In the past, preparing panels for tempera and canvases for oil was a skilled and exacting task, not to be undertaken lightly. Before the grounds were applied to the surface, a coat of animal glue size (usually rabbits' skin) might be needed to separate the surface from the priming. In the case of oil painting, this was mandatory as oil paint will rot unprimed canvas if placed directly upon it.

If the priming was brittle, as in the case of plaster-based primings, known as gesso, canvas could not be used at all, as it was far too flexible, and the priming was not. Gesso could only be used on a perfectly rigid support like wood, that had to be properly seasoned, otherwise warping and splitting might occur.

Making glue for primings was a long and tedious operation. A double glue boiler was needed to melt the glue, and when ready the smell could be rather strong. Furthermore it had to be applied hot.

Making gesso was equally arduous – to make as well as apply. Anything up to eight coats were normally applied, and if not done correctly would crack and flake.

With acrylic all this is avoided completely. Acrylic needs no special glues or primings. Acrylic sticks so well, it can attach itself, without harm, to almost anything. There are only two treatments for priming a support: either the

CLEANING A BRUSH

1 Rinse the brush in a widenecked jar of clean water.

2 Reshape the brush by drawing it backward through the palm of the hand.

3 Allow the brush to dry by storing it up-ended in a jar.

HHRDROHD SHOOTH SIDE

PLYWOOD

acrylic medium, or white acrylic priming which can be bought ready-made.

SUPPORTS FOR ACRYLIC PAINTING

IN THEORY, YOU CAN use almost anything as a support for acrylic painting. There should be no problem if you bear in mind these six points:

All surfaces must be absolutely clean. Any oil or wax present, even in minute quantities, will prevent the acrylic adhering properly.

Ensure that any unprepared hardboard, or equivalent commercial board, has no oil or wax in its manufacture.

Any oil-primed wood, canvas or board (ostensibly for oil painting) should not, under any circumstances, be overpainted with acrylic. Check the maker's instructions very carefully on this point. If in doubt do not use at all.

Very smooth surfaces, like glass, polished metal or plastic, may appear to hold acrylic paint, but in fact may scratch easily, or even flake or peel off if in contact with dampness, unless slightly roughened before painting. Wirewool, sandpaper or some other tool that will scratch or indent the surface can be used to give a tooth.

Avoid silk. It is rather too smooth, and not nearly robust enough for good adhesion. Also avoid unseasoned wood, as it will warp or split in time, and large sheets of hardboard, unless properly backed by battens or frame, will sustain damage at the corners unless protected.

Avoid painting on very rough surfaces. For example, murals and wall decorations should not be painted directly on to brick or concrete without some kind of treatment first. At least three or four coats may be needed.

PRIMING

PRIMING SURFACES for acrylic painting requires only white acrylic primer, which is easily and quickly applied with a household brush, roller or palette knife to wood, canvas, card (cardboard), paper or hardboard.

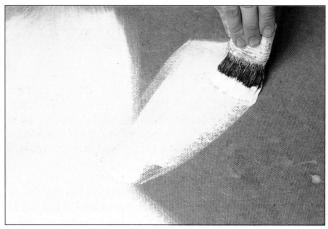

ABOVE White acrylic primer is applied to hardboard with a household brush.

HOW TO STRETCH A CANVAS

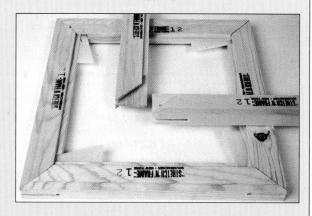

1 Wood for stretchers is available in many lengths,

which can be fitted together to make rectangles of all sizes.

2 Slot the stretchers together so that the corners are at right angles—the diagonals should be of equal length.

3 Cut the canvas to fit, allowing a margin of 5-6cm (2-3in) all round.

4 Fold the canvas over and staple it to the stretcher, starting in the middle of the longest side.

5 Staple towards the corners at 8cm (3in) intervals. Repeat on the opposite side and then the shorter sides.

6 Turn the corners diagonally. Staple both edges firmly into position.

7 Tap the corner wedges into place. The fabric should be tight but not taut. The fabric is now ready for priming.

Anyone who has painted a wall with emulsion paint will be able to prime a piece of hardboard or card successfully, for the job is identical. The acrylic primer can be applied directly from the jar, or thinned with a little water if too thick.

Two thin coats should be sufficient to cover a piece of hardboard – the aim is to obliterate completely the colour of the hardboard – whereas one coat might be sufficient for a piece of white card (cardboard). There is no need to size the hardboard, but if it is highly absorbent, it can be made less so by brushing on a thin coat of acrylic medium before priming with white. And if too shiny or smooth, it can be roughened with a piece of sandpaper to give it a tooth.

If you prefer the natural colour of the support, you can brush on a thin coat of acrylic medium, matt or glossy, to seal and prime the surface. Any further painting can proceed as if it were primed with white.

CANVASES

READY-MADE canvases, primed for acrylic painting, can be obtained at most art supply shops. The acrylic canvases available might need an extra coat of priming to give the tooth required. Somehow (and here personal preference intrudes), I feel that canvases are best left to oil painting, and the natural and primary supports for acrylic are the more rigid and firmer supports like card (cardboard) and hardboard and, of course, paper.

The disadvantages of canvas tend to outweigh their pleasant handling qualities and lighter weight. Canvas is vulnerable. It is prone to damage, the expansion and contraction of the cloth in varying temperatures will place a great strain on the priming, and cause cracking and flaking. The more flexible acrylic can cope with this hazard, but cannot avoid damage by denting, and the kind of wear and tear a more rigid support can sustain.

Thin coats of acrylic medium might help to stiffen the canvas a little and make it a little less fragile, as would keeping the canvas taut by knocking up the corners with the appropriate wedges whenever possible. Do not lean things against them, for any creases or dents that may occur will be very difficult to remove.

Bought canvases, stretched and ready for use, are convenient, but expensive. Making your own is not only cheaper, but is also more satisfying if you have the time. For make no mistake, you do need time and space to do the job properly. Either a good wide table or workbench or the floor will do, provided the canvas can lie perfectly flat, and is unimpeded, so that you can either turn the canvas satisfactorily or move around it easily.

The canvas is made up of two distinct materials, before priming: wood for the stretchers and keys (wedges), and the canvas itself, which might be made from cotton or flax and be woven coarse, medium or fine.

There are two kinds of stretchers: the interchangeable kind or the fixed. The interchangeable are known as wedged stretchers, and have a specially cut end that will firmly wedge together. When made up with canvas, they can be stretched tightly by the insertion of small triangular

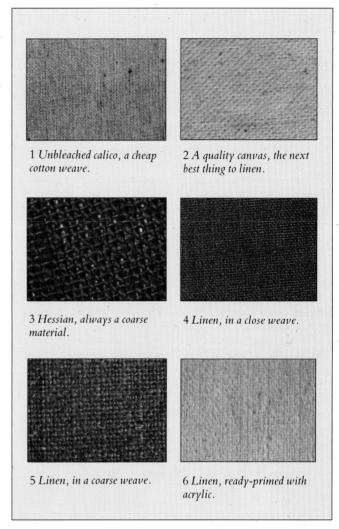

shaped pieces of wood into the specially cut slots. Gently tapping them in with a hammer will pull the canvas as tight as a drum.

Wedged stretchers come in many lengths up to several feet/metres, and up to 3 in/8 cm in width. They are grouped in categories according to size, and within these categories they are interchangeable. They should be easily obtainable from a goo'd art supply shop, which should stock all sizes.

■ RIGID OR FIXED STRETCHER

Most painters find that the wedged stretcher is the most suitable for making their own canvases, and the most practical for working on, mainly because the canvas can be kept fully taut by the use of the wedges at the corners. If for some reason the right size cannot be obtained, making them yourself can be a problem. Wedged stretchers have a complicated cut end made to ensure accuracy. If they are badly made warping, among other things, will ensue, and it will be out of true at the corners. It is essential that, when a canvas is made up, the angles should be at 45 degrees, or else the canvas will develop folds and look unsightly.

As a substitute for a wedged stretcher you can construct a simple fixed frame, made from bought, 2 by 1 strips of

wood. These can be cut to size and properly mitred and glued to ensure that it will take the strain of the taut canvas.

As these frames are rigid, they cannot be tightened at the corners with keys or wedges should the canvas become slack. This means that the only way to keep the canvas tight is to restretch it. In spite of this, many painters continue to use them especially for painting on odd-shaped canvases. Since the introduction of acrylic paint, many painters have broken away from the traditional rectangle, to exploit unusual shapes to paint on. Oil paint seemed to demand the rectangle (and the occasional oval) shape to work on. Among other things, acrylic allowed the painter to break away from conventional practices and try new approaches. The odd-shaped canvas was one of them.

Rigid frames impose a number of conditions, one of which is to make sure that the canvas is absolutely taut before priming. Many painters who use fixed canvases tell me that they try to stretch the canvas unprimed, if possible, and then give it a thin coat of acrylic medium. They maintain that this stretches the canvas taut when dry, and then a thin coat of acrylic priming can be put on without any slackening at all.

When an unusual support is required, another answer is to use hardboard, which can be constructed much more easily than a rigid stretcher. If a canvas surface is desired, it can be glued on (marouflaged) to the hardboard, and no arduous stretching will be necessary.

An odd-shaped support made with hardboard can be rather heavy to transport, as it will also need strong battens at the back to prevent it from warping. Hence the popularity of canvas – even on a rigid support.

■ STRETCHING THE CANVAS

Stretching can be done with either raw or with primed canvas. Primed canvas can be bought, but you can prime it yourself. The procedure is exactly the same as for hardboard – two thin coats straight from the jar. For a smoother finish a third coat may be added.

If done on the stretcher you can make a neater job, whereas priming un-stretched canvas can be rather messy. I usually stretch five or six unprimed canvases at a time. I can then prime them all at once, or just one or two. Acrylic priming dries comparatively quickly, which means that the tedious business of laying two or three coats can be speeded up.

To stretch either primed and unprimed canvas: cut the canvas 4 in/8 cm longer and wider than the stretcher, to allow for overlap. Place on a flat surface and place the stretcher on top of the canvas. Fold one edge of the canvas over the frame and tack or staple it in the centre of the side. Then do the same to the opposite side, then to the two remaining sides.

When tacking is completed make certain that there are no folds or creases at the corners before priming. It is unnecessary to wedge the corners at this stage. When the priming dries out the canvas will tighten automatically, provided the priming is thinly applied.

Priming canvases can be done with brushes, knives or rollers, as with hardboard.

EASELS

THE LAST, IMPORTANT PIECE of equipment is the easel. The easel carries the support. For large supports, and especially canvases, the easel is best placed firmly on the floor. Ideally suited to this purpose is the radial easel.

For smaller sized supports, a table easel can be used as an alternative. Also when space is at a premium, it can be folded up neatly and put away, unlike the radial type which will take up room however you stack it.

The lighter, more mobile easels are designed principally for outdoor work where walking or moving about may be involved. They can, of course, be used in the studio quite adequately for small supports, if required, and so duplicate their value.

The radial easel is a well-made, versatile piece of equipment, that can move backwards and forwards, and hold large and small supports. The height can be adjusted and it can be tilted. The table easel varies between a more elaborate adjustable kind and a simple fixed kind that merely props up the support or board for paper.

The table easel is much more convenient for free-flowing or washy paint, where the suport needs to lie fairly flat so that the paint does not run all over the place. For thicker paint, a radial easel will be found to be more suitable.

An easel of some kind is absolutely necessary for most kinds of work. Unless you paint on a workbench or on the floor, even a block of wood will do at a pinch to prop up a support in the studio. Outdoors, because of the quick drying qualities of acrylic, the support may be rested on the lap or on the ground. However, an easel is an essential piece of equipment.

SUMMARY

TO SUM UP, THE essential requirements for acrylic painting are: several water containers, palettes, palette knives, brushes, supports and easels.

Of the accessories, clean rags are for mopping spills, cleaning palettes, wiping knives and brushes, and keeping hands clean. Kitchen paper towels will do the same job.

Sponges are useful for wiping and mopping up, and can also be used for painting and making textures.

Razor blades will be very useful for scraping, scratching old paint and for texture on the painting itself. They can be used for painting with, as a substitute for a painting knife.

A trimming knife has much the same uses as a razor blade, though it is more difficult to paint with. It is the flexibility of the razor blade that enables it to be used with paint.

Drawing pins (tacks) are always useful to have about, for pinning paper or card (cardboard) to working surfaces, for tacking canvases, or for pinning up work, for criticism or display.

Finally the spike, or needle – a useful tool for poking into the necks of tubes to clear them of any hardened paint.

ESSENTIALS

- water containers
- palettes
- palette knives
- brushes
- supports
- easels

ACCESSORIES

- clean rags or kitchen paper towels
- sponges, real or plastic
- razor blades or trimming knife
- drawing pins (tacks) or staple gun

This can happen with acrylic paint, however carefully you screw back tops. Nothing is more frustrating than picking up a tube of paint in the middle of work and discovering that the tube won't squeeze properly because of a little dried paint at the top. Acrylic dries so hard and so well that, without a tool like a spike, it will remain stubbornly intact no matter how hard you squeeze. And the pressure of squeezing may burst the bottom of the tube throwing wet paint about everywhere. It has happened, so keep a spike handy just in case.

Just a word about what to wear. Acrylic paint adheres to almost anything, and especially to fabric, so it will be extremely difficult to remove from clothes. Although paint solvent and remover may serve in an emergency, the best advice is: wear old clothes.

BELOW There are many types of easel.

1 Studio easel, ideal for work on large canvases.

2 Radial easel, may be folded down and tilted backward and forward.

3 Artist's donkey, suitable for working while sitting down.

4 Table easel, best used on a low table or with a tall chair.

5 Collapsible easel, good for outdoor work.

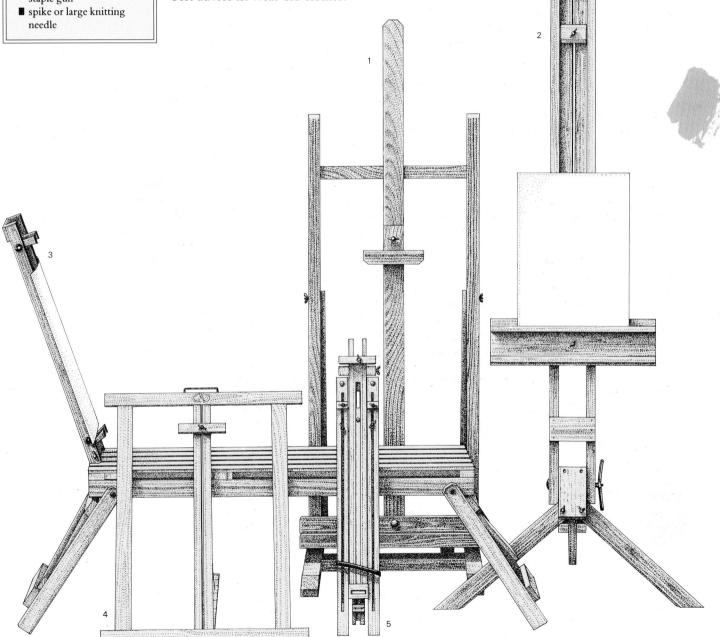

CHAPTER THREE

PAINTING WITH ACRYLICS

the simplest of paints to use. The minimum amount needed is a few tubes of paint, some brushes, a palette and water. This is not to say that watercolours or acrylics are the easiest paints to use because the equipment needed can be reduced to the bare minimum, but because of its basic simplicity, acrylic can give enjoyment from the very start.

MANY PAINTERS AND DESIGNERS make a practice of combining acrylic with other media like coloured inks, drawing or gouache. Acrylic seems to work well with almost any conventional medium, provided it doesn't contain oil.

The reason for including information on what must seem like so much equipment is that it can be used when needed should it be required. Those who have painted with oils will know how much basic equipment is needed just to begin. Happily this is not so with acrylics. Paints, paper, brushes and water are all that will be needed. With exerpience newer items will be added and others discarded.

THE INFRASTRUCTURE OF PAINTING

LOOKING AT A PAINTING or design is rather like looking at an iceberg. We only see the tip. We can't see what's underneath holding it up, as it were. We know, however, that a great deal of the iceberg is beneath the water – hence its strength.

The strength of a painting, too, lies beneath the surface – and has dangers for the unwary as well as delights. If this fact isn't understood, painting will forever be a mystery.

Actually the principle is very simple and quite easy to understand. It is this: paintings are built up in layers. Even watercolours are built up with layers of washes, one transparent film over another.

This layering of one coat of paint over another varies with the function of that layer. For example the function of the primer differs from the function of a glaze: the primer, because it is a sealer and a reflector of light, is thick and opaque; the glaze is thin and transparent because its job is to let the light, or another colour, come through.

For most household jobs, the paint layers would be fairly simple: sealer, undercoat, top coat.

For painting in oil or acrylic the number of coats or layers could be as many as ten. For example, starting from the bottom:

LAYERS OF A PAINTING

- SUPPORT: PAPER, CARD, CANVAS, hardboard etc.
 sealer: glue size or acrylic medium (optional for acrylic, necessary for oil)
- primer: gesso, acrylic white, lead white etc.
- wash or toned drawing
- underpainting: blocking in the main areas of colour, usually thinly
- middle layer
- scumble
- **impasto**
- glaze
- varnish

This is precisely what painting entails: a study of the layers of paint. The success of any painting depends on how they are amalgamated. Naturally only a few of them may be used on any one painting, but to get the best out of acrylics it is essential to be acquainted with them. Fortunately acrylic dries quickly, so the process of laying one

coat over another can be speeded up, and takes much of the tediousness out of painting. Oil paint, being a slowerdrying paint, hasn't this advantage.

The study of paint layers goes hand in hand with a study of colours and the way they interact with each other. Before that, we have to consider another important factor – water.

WATER

A NUMBER OF MEDIUMS have been suggested for use with acrylic paint to make it flow better, to give different finishes – gloss, eggshell or satin, matt – to produce every kind of impasto from medium, to thick, to very thick, and to retard the drying rate. But the most important of these, the medium that takes precedence over them all, is the diluent itself: water.

Acrylic paint is made up from three components: pigment, binder, water. Water plays a dominant part in painting with acrylics, not only for the vital process of thinning the paint to the required consistency, but also for cleaning brushes and palette. Without water, painting with acrylics becomes irksome, if not actually impossible.

Literally one must study the behaviour of water, for apart from its thinning and brush cleaning propensities, it must play its part throughout the whole of the work. Water is the life blood of acrylics, and though the other mediums extend the range of achievement, one can, at a pinch, do without them – as many of us did when acrylic paint was new and largely unknown. Consequently we were forced to examine just how much we could do with water alone.

By giving water the central role to play in acrylic painting, you learn that the amount used largely controls the rate of drying. It is essential to remember that once the water evaporates the paint hardens and cannot be redissolved with any more water (as it can with watercolour and gouache).

With experience and experiment you learn to add just the right amount of water to produce: the right consistency and the appropriate drying time to allow for working. This produces the simple rule: the more water used, the thinner the paint and the longer the drying time.

The four main forms of consistency are: thin, thick, transparent, opaque. Some of them can be amalgamated by the use of water alone: thin/transparent; thin/opaque. However, the only way to admix thick and transparent is by the use of a gel. Similarly the only way to get a really thick paint is by the addition of acrylic texture paste.

For the rest, water is sufficient.

Because acrylic is a water-based paint, it is always the practice to wet the brush before use, especially for mixing paint. As a general rule, never use a dry brush for anything pertaining to acrylic. A dry brush won't allow the paint to flow properly, will alter the drying times so that it will be harder to gauge, and won't do a sable brush much good. However if it does transpire that a dry brush has inadvertently been used, wash it out immediately afterwards.

(The exceptions to this rule will be seen in the section on scumbling, but here old brushes are recommended.)

This means acquiring, early on, the habit of constantly dipping the brush into water, and shaking out the excess, before beginning.

You can do the same with a palette knife – moistening it before use – though of course, the knife won't retain the water to anything like the same degree.

CHOOSING COLOURS

THE NEXT, AND MOST important, stage, is choosing colours, then mixing and applying them. The following colour exercises are very basic and, to get the maximum benefit from them, thin opaque paint, rather than thick or transparent paint, is recommended. The latter kinds of paint will be gone into later, and may be adapted to the exercises accordingly.

Choose a palette that will hold the paint well. Thin paint does have a tendency to slop about. Try the kind with wells or use a small saucer or two.

Another point to note is that once acrylic paint is mixed, it will last indefinitely so long as the water in it doesn't evaporate. Therefore any colour that has been mixed, and for any reason isn't needed right away, can be kept in a small jar or container so long as it is properly stoppered. For this purpose, I use discarded film cassette canisters, which are ideal for ready-mixed paint, and are useful for taking outdoors for working. A dab of the colour contained in them on the lid of the canister identifies them immediately.

Choice of colours is the very heart of painting and designing. The question is how to go about it? What are the rules, or principles, if any, that apply?

The overwhelming compunction on seeing a colour chart for the first time, is to want them all – and then give up because the choice is so wide, so it is refreshing to be told that the maximum number of colours needed to make up a palette that will do practically everything is FIVE.

FIVE ESSENTIAL COLOURS

- white is absolutely mandatory in any palette, for mixing tones and tints, for repainting prior to glazing or alteration, and as a colour.
- Black is essential for tones, and as a colour.
- Yellow primary.
- Red primary.
- Blue primary.

The three primaries, yellow, red and blue can be mixed to make three further colours, or secondaries: orange, green and violet in the following way.

Yellow and red make orange.

Yellow and blue make green.

Blue and red make violet.

The secondary colours – orange, green and violet – can be bought in tubes ready-mixed which, if preferred, will make the basic eight-colour palette.

Whether you decide to have a five or eight palette,

mixing primaries to make secondaries must be carried out at some time for the experience of seeing what happens.

As an aid to choosing colours it is helpful to use a colour chart. Charts give the best information on the tone and range of the selection, the names of the colours, and a note or two on their use and permanence. Moreover charts are good to refer to for other reasons. By being the standard or yardstick of what pure colour looks like *before* mixing, they will aid mixing by being a reminder of what they were. With colour, the way to enhance understanding of them is to experience them often.

You can learn about colour by theory or by painting from nature: still lifes, landscapes, portraits, nudes and so on. Both methods have their respective value as a means of understanding colour. But for many students, especially beginners, studying colour directly from nature can be confusing, for the very reason that nature tends to get in the way. Degas once remarked to a student: 'If you want to learn to paint, don't study nature, study paintings.'

The colour-mixing exercises that follow take this observation one stage further, and concentrate solely on mixing and applying the paint. By so doing, you will experience exactly what colour does when mixed and applied. The exercises are fairly easy to carry out, and the results are immediate.

Begin with well-balanced and versatile hues. I would recommend yellow, red, blue. To these primaries I would add as secondaries orange, green, violet.

The ochres, umbers and siennas can be mixed approximately from the six-colour palette suggested. They may be added to the palette later, if required.

To explain why I have laid so much emphasis on the hues, the nature of colour temperature needs some explanation. Briefly, colours are either warm or cold depending on whether they are closer to one end of the spectrum or the other. Warm colours are those closer to red. Cold colours are those closer to blue.

Most colours have a bias one way or the other. Balanced colours, neither too warm nor too cold, are ideal for mixing secondaries from primaries.

Mixing primaries together to make secondaries is a delicate operation for those unused to mixing them, because the mixtures must be perfectly balanced. If the mixture is orange, it must not be too yellow or too red. With balanced primaries, it is much easier to judge.

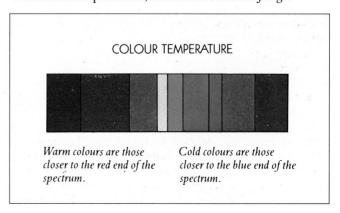

MIXING ACRYLIC

TO GET USED TO the way acrylic behaves, and to get the feel, as well as the visual impact of a mixture, a sound practice is to begin mixing each colour – both primaries and secondaries – with white first, and then with black. Then add black to white mixes, and white to the black.

Mixing white with a colour is referred to as a tint.

Mixing black with a colour is referred to as a tone.

All colours, whether pure or mixed together on the palette, can be toned or tinted with the addition of black or white. To grasp the range of tones and tints, and the extent to which they can be manipulated, all the colours that are available should be tried out at some time.

The point of this is that once the visual experience of mixing colours has taken place it will remain as a guide for future reference. Once seen, never forgotten. The more mixing that is done now, the more confident will be the results later. The results of these experiments should be kept, at least for a time, as a reminder.

COLOUR MIXING

EXERCISE 1 – LIGHT TO DARK

THE VERY FIRST EXPERIENCE with mixing can be with just white and black, before trying out the other colours. It is slightly easier to judge tones and tints of grey than the tones and tints of primaries and secondaries. This exercise is basic to all the colour mixing exercises. It will incorporate mixing, applying and experiencing the visual impact of tone, tint and hue.

Mixtures should be well integrated, on the palette, with a knife, and with enough fluidity to allow the brush to

make a good, clean stroke.

For the kind of grid that will suit this exercise best, use six squares, about ½ in/1 cm in size, which can be conveniently filled with variegated tones of paint from light to dark, and from dark to light.

Method 1. Add black to white, to make a series of greys, from the palest to the darkest tints, in six steps. The grey of medium strength should occur in the centre of the scale.

This exercise can now be repeated with all the colours, one by one, included in the palette, utilising Method 1 to make tones, and Method 2 to make tints.

Points to remember, observe and develop:

1. These exercises are fundamental. There is no need to paint them carefully, if your natural inclination is to paint

them freely. The practice should be as enjoyable as posible. The only proviso is that care should be taken in the mixing of the paint, so that each change of tone, in its respective square, is as clear as possible.

2. There are no rules; and no end product to cause worry. The main point is, that when trying any new colour, do it this way before using it for whatever purpose you have in

mind.

- 3. The aim of this exercise is to sharpen sensitivity, and give valuable experience not only in mixing colour, but to see what the colour looks like when mixed.
- 4. The exercises can be carried out in any order; size is optional, but for the best results, white paper or card (cardboard) is recommended, primed or unprimed. For a primed white surface one thin coat is sufficient.
- 5. The grid may be varied to accommodate more tones and tints, and more colours. As a variation, the tones and tints may be further mixed horizontally as well as vertically.

BELOW LEFT The grid with separate tones.

ABOVE The horizontal and vertical grid.

6. As an alternative exercise the mixing may be carried out without using white. The colours can be lightened by the addition of water to make them more transparent. This is the same technique as is used in painting with water-colours. It is a useful exercise, but needs more care than in using opaque acrylic, as the washes are more difficult to control. However, whatever result is obtained, practice in using colour this way is valuable, if only to experience the differences between using opaque and transparent colour. As a further experiment the exercise can be carried out on

different surfaces (as with watercolour) with both primed and unprimed paper.

7. Painting can be done with knife or brush. Try experimenting with them all, at some time or other, and become familiar with them at every available opportunity. This is the true meaning of practice.

8. Once confidence in mixing is acquired, any other acrylic colour may be tried out – the umbers, siennas, ochres, as well as the cadmiums, blues and greens mentioned earlier.

WHITE PAINT

WHITE PLAYS A MOST important role in painting and you will need more of it than any of the other colours. If possible buy the larger quantities. Large tubes will be less troublesome than small tubes which will run out very quickly. There is no good reason that I can fathom why one cannot use acrylic primer, if one does run short, as it is made of the same pigment, titanium white, and acrylic binder, as the tubed titanium white.

Titanium white is the only white pigment used, at the moment, for acrylic white paint, and is very powerful. A little goes a long way. So one has to be careful when mixing to add the white sparingly, or strong colours will be reduced to tints surprisingly quickly.

With jars of white, be very careful to keep the tops of the containers clear of dry paint, or the water will evaporate and the paint harden. A good tip is to sprinkle a few drops of water on the white to ensure that it doesn't, before putting the lid back on.

BLACK PAINT

MARS BLACK, WHICH IS absolutely permanent, is manufactured from artificial oxides of iron and is rather powerful so that, like white, it should be mixed sparingly with other colours. Although its use is suggested in the exercises, tones can be produced with many other combinations of colour – red and green, for example, make very good grey-blacks, as do blue and umber. Black is nevertheless a good utilitarian standby and an ideal colour for beginning the mixing of tones without too many problems.

EXERCISE 2 - DIRECT VISION

I HAVE MENTIONED BEFORE that learning about mixing and applying colours can be done directly from nature, but that the process can be confusing to those unused to the practice. As a bridge from mixing colours on a systematic chart basis as in Exercise 1 to the full examination of colour in nature which will lead to the painting of pictures, the following method is a simple and easy step in that direction.

Colour mixing and application are exactly as in Exercise 1.

1. Thin, opaque paint.

ABOVE The tonal scale runs from white to black. Every colour has a

tonal equivalent on that scale between light and dark.

- 2. Primed or unprimed paper or card (cardboard), size optional but not bigger than 33×22 in/84×56 cm.
- 3. The choice of brushes is again optional.
- 4. Black and white paint are mandatory.
- 5. Three primaries only to begin with: red, yellow and blue; other colours can be added later for further experiments.

The aim of this exercise is to examine one colour at a time in all its variety, subtlety and visual impact by observing directly a group of objects all of the same colour.

To carry out this exercise, select a number of objects of the same colour: red, yellow or blue (omit green for the moment). Though only one of these colours is to be used at a time, the more varied the shades, the surfaces and the size that can be assembled the better.

If a particular colour is chosen, say red, to begin the experiment with, it will be immediately noticed that reds vary enormously. Some are warmer, others colder. Shiny reds will appear quite different from matt, some will be darker than the others and so on.

As an aid to selecting objects use this framework as a guide:

- 1. Size: large, small, cylindrical, cubic, round, triangular or concave.
- 2. Surfaces: smooth, rough, shiny, matt, textured, patterned.
- 3. Tone: light, dark, brilliant, faint, harsh, soft.

As a general rule three objects on a similar colour background are sufficient to begin with, arranged so as to make the maximum effect of the colour obvious.

The painting can be done either freely, in broad brushstrokes or flatly, in simple plain-coloured areas.

The object of this exercise, whichever way it is painted, is to mix different tones and tints of the same observed colour. The experience of Exercise 1 will be of great help here, and the painted charts can be referred to constantly if need be. The exercise will be helpful in making the eyes colour-sensitive to the gradations and variations of tones and tints that make colour so fascinating and elusive to control. This particular way of observing colour will enable you to grasp the essentials of manipulating colour.

The suggested method of painting to adopt is as follows:

1. Establish the large areas of colour first: this is usually the background, but if there isn't a great deal showing,

begin with the largest shapes instead.

- 2. Use the brush to make deliberate marks of paint. Let the brush do the work. Avoid strain and above all avoid scrubbing. Load the brush with as much paint as can be held comfortably, and when exhausted replenish with fresh paint. Don't ever scrub with a dry brush. It will ruin the hairs, and make an unpleasant mark. Let the brush flow freely
- 3. Build up the shapes of tone with crisp dabs of paint. Make no effort to make the painting look 'real'. Aim instead to examine the different areas of colour, and try to

state them as approximately as possible. Don't strain to make a picture, let the paint and the colour dominate instead.

This exercise should be repeated using all the primaries. It can then be followed by exploring the secondaries: green, orange and violet.

Variations on this theme can be made by:

- changing the background to a different colour from the objects
- 2. introducing one object of an entirely different colour
- 3. introducing a white and black object to create a contrast
- 4. introducing two different coloured objects
- 5. painting on a coloured support
- 6. changing the background to black
- 7. changing the background to white.

COMPLEMENTARY CONTRAST

complementary. Colours are those that lie opposite one another in the colour circle. As a follow up to the last exercises, and for further variations on colour combinations, here is the way in which complementaries work in contrast with one another. They make an interesting point about the way we respond to groupings of colours, and it is absolutely essential for designers to know what they consist of for future use.

Examples of primaries and secondaries consists of: yellow, violet, blue, orange, red, green. And in all these pairs primaries are always apparent – hence the necessity of mixing them together to make secondaries in the early stages. One gets to understand them better by doing so.

These colours are opposite yet require each other: they produce a vividness when adjacent, yet annihilate each other when mixed to produce a dark grey (useful as the basis for a neutral background, or underpainting to work on).

Another useful peculiarity of contrasting complementaries is that, though opposite, they have the remarkable ability to appear perfectly harmonious. This makes

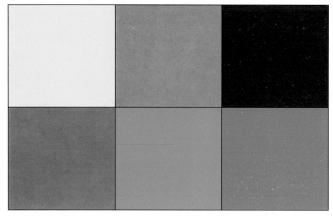

ABOVE This chart shows the primary colours, yellow, blue and red with their contrasting complementaries, violet, orange and green, respectively.

ABOVE RIGHT A similar complementary contrast chart incorporating intermediate tones and tints.

using them an agreeable pictorial device for enhancing both paintings and designs. By utilizing the complementary chart, you have the beginnings of ready-made colour schemes that can be easily carried out with acrylic.

In the top row of squares move through yellow, orange, red, to violet, and the bottom row from violet, blue, green back to yellow. Begin with the primaries and secondaries directly over their opposite, and place the intermediate tones and tints in between in their correct order. The gradations of green should be placed under the appropriate gradations of violet above.

As an additional exercise, painting your own colour circle will give valuable experience in trying out colours straight from the tube without any mixing at all. Alternatively the secondaries can be mixed from the primaries to observe how possible it is to do so successfully.

Whichever method is adopted, it will remain as another interesting alternative in exploring the possibilities of colour.

Complementaries, and indeed, colour generally can be further studied with profit. Another simple experiment is to try painting on a coloured underpainting. Usually you begin on a white surface. Painting on a coloured surface opens up a great number of possibilities, too many to start with perhaps.

COLOURED SURFACES

distinct categories: naturally coloured materials, such as wood, unglazed ceramic, metal, linen, hardboard etc; artificially coloured materials, like pastel papers, mounting card, plastic, dyed fabric etc.

Possibly the best surfaces of all are those you prepare yourself. Ready-made surfaces are rarely as versatile or satisfactory enough to suit all requirements. Those you prepare, moreover, have the advantages of better control of the work from its inception. The appropriate coloured surface will aid judgement of the tone of the colour – which a white or, for that matter, black, surface will rarely do. The reason for this is not difficult to find when considering tone. The addition of white or black to a

primary or secondary colour works within a tonal scale that has white at one end and black at the other. This is in accordance with one way the natural world is seen: as gradations of dark and light. This tonal scale moves in a series of progressions from one end of the scale to the other. To find the right balance within it is more difficult to judge, if we are forced to work from one end or the other. If instead we begin in the middle and work outwards, the result will be more successful, more visually effective and, more important, will be much more enjoyable to do.

Working in the middle of the tonal scale means darkening the white surface to a grey or neutral (middle tone) of colour. (As you rarely work on a black or very dark surface the problem won't arise with the same insistency.) For a white ground or surface the mid-tone can be varied in a number of ways:

1. It can be either flat or broken. A broken ground offers a number of additional possibilities over a flat ground, and was the kind often used by the old masters. Usually it was a wash or stain of diluted umber, but red ochre was also often employed, as well as neutral greys.

2. Greys can be mixed from complementaries and tinted with white, or from black; both make good backgrounds or underpaintings to work on.

3. Another practical neutral tint can be made with raw umber, rather than burnt umber which tends to be very warm. Raw umber, having a slightly greenish tinge, is cooler and just about right for making mid-tones that won't conflict with the colours painted over them.

4. A mid-grey tint can be further tinted with a primary to make a coloured grey, and a broken 'optical grey' can be made with patches of greys and coloured greys, to create a more lively surface to paint on – rather like an Impressionist painting in fact, but without the bright colours and the small brushstrokes.

Utilizing these kinds of grounds by painting the still lifes recommended in one of the exercises will be even more exciting because here you will be able to use with acrylic a number of accepted oil painting techniques with complete comfidence: impasto, palette knife, glazing and overpainting.

IMPASTOS

IMPASTOS ARE THICK, HEAVY strokes of paint made with brush or painting knife, and commonly associated with oil paint. With acrylic they can be achieved straight from the tube, like oil paint, and by the addition of either of two mediums, gel and texture or modelling paste, can be made as thickly as desired – something that can only be done with difficulty with oil paint, as oil paint dries slowly and cannot be thickened beyond a certain point without damage to its inherent and visual appeal.

Impastos have a direct, spontaneous visual impact, and are attractive to look at, and for many painters are easier to handle than thin paint, especially with a knife. But though attractive and pleasant to do, impastos can easily become an indulgence and so lose their initial charm unless

something is done about extending their capabilities by experiment and experience. Therefore they should be tried not only straight from the tube, but with gel and texture paste, and with a knife and brush separately and in combination. Impastos are intensified and conversely made more subtle when glazed.

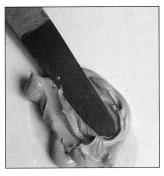

1 The artist uses the knife to mix the paint on the palette. He then spreads it thickly in broad, textured ridges.

2 A heavy impasto may be sculpted to produce swirls and ridges.

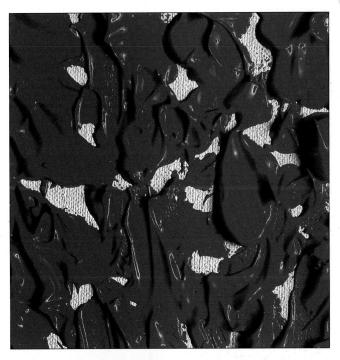

1 Use undiluted acrylic paint from the tube, or mix tube colour with an equal proportion of gel medium.

2 Use a knife or a stiff bristle brush to spread the paint on the canvas.

ABOVE When applying impasto with a brush, mix the paint to a fairly stiff consistency. Dab the paint onto the support. Spread and shape it as required. The brushmarks will form part of the composition.

KNIFE AND BR<u>USH</u>

THE PAINTING KNIFE ON its own has an important role to play especially for those unused to a brush. But essentially what gives impastos their value is the directness with which they are done. Mess them about by too much overpainting and the vitality is severely reduced: you end with tinted mud.

The knife is probably less liable to mess, in spite of being clumsier than a brush. The flat blade of the knife constructed for mixing merely remixes the paint when applied to painting, whereas the brush being less able to mix, will only stir the paint up. Brushing paint should therefore be very deliberate, and if the sweeps and swirls fail to delight for whatever reason, scrape it off with a knife before it dries too hard, and start again.

The fact that some paint will be left will make a good underpainting for what is to follow, for some impastos work better, and look better, with an underpainting.

The main points to observe when mixing paint and medium for impastos are:

- 1. Make sufficient quantities of colour you need more than you think.
- 2. Mix the medium well into the paint, take some time over the operation, or the impasto will lack the bulk the medium will give.
- 3. Impastos are also heavy, by comparison with thin opaque paint normally used, therefore only mix with a palette knife, never a brush. Application, on the other hand, can be done with either.
- 4. The visual impact of impastos are ridges of paint and lively brush or knife marks. These effects are best retained if the paint is not over-worked too much.

A glaze will bring out the unique features of impasto if applied carefully. But glazes can do a number of other things equally well. And because of the special qualities of acrylic mediums, they can do the job quicker and more effectively than oil paint, and may be used frequently without any bother, as the normal process of using acrylics.

ABOVE An alternative method of applying impasto is to use a small palette knife. Scoop up some paint and lay it on the support. Spread and shape the impasto.

TEXTURAL IDEAS

ABOVE A thick layer of acrylic mixed with modelling paste is applied with a painting knife and smoothed out.

ABOVE A kitchen fork is pressed into the wet paint to produce a pattern of grooves and ridges.

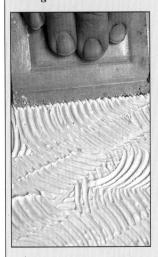

ABOVE An adhesive tool is used here. By twisting and turning it, many different patterns may be made.

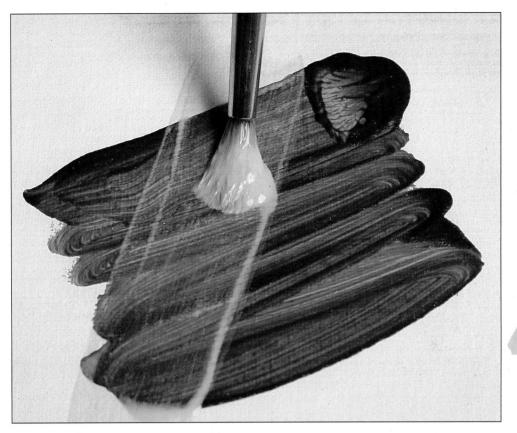

GLA7FS

IF IMPASTOS ARE THE thickest paint used with acrylic, then glazes are the thinnest – thinner even than the washes. Briefly, glazes are a mixture of medium and transparent pigment which is applied over dried underpaintings. The colour of the underpainting blends with that of the transparent glaze, and because it is not mixed with it, has an optical effect which is more vital than if it had been.

Glazes are, in effect, transparent coloured windows, and behave not unlike sunglasses – reducing the amount of light, and slightly changing the colour. Of course with coloured glazes, one tries to enhance, rather than reduce the colour, but to take the example of sunglasses further, glazes can and do have the power to unify the tones and tints of a work by reducing the colour, much as sunglasses do. Many a discordant work has been harmonized by placing a dark glaze over the whole of it.

Acrylic glazes are entirely free from being reduced to single colour glazing, because both they and the underpainting dry so quickly. As many glazes as required may be applied one after the other in a matter of minutes. The result is unique. Something that only stained glass could effect in the past – bright, rich, transparent colours, an effect that allows the light to pass through and so give an almost luminous glow to the colours. A good form of practice is to make glazes, on card (cardboard) or paper, using as a framework both the exercises given previously or the one that follows.

ABOVE To make this glaze, mix a small amount of colour with a lot of medium. Apply with a soft brush and allow to dry.

ABOVE A more transparent glaze can be made by adding extra matt medium to the pigment.

ABOVE A transparent scumble is made by mixing a lot of matt medium and water with the colour to produce delicate scumbles. Further scumbles can be built up in layers to give greater effect.

BELOW Use short, irregular strokes to produce an area of broken, scumbled colour.

EXERCISE IN GLAZING

FOR THE EXERCISE ONLY, a small piece of card (cardboard) or paper is necessary. But to get the most out of it, both plain and primed supports should be tried. Glazes should be as thin as possible, which makes them fragile, because the binders are weakened. Therefore the addition of a medium (in this instance the binder itself) is absolutely vital. Also the medium gives body to the glaze, which the pigment fails to give. As a beginning, to get used to the feel and visual impact of glazing, use the acrylic medium alone. If it feels too thick, add a few drops of water – the cardinal rule.

The exercise can be repeated with gel medium, both with brush and knife. Glazes can take on a different quality with a knife, and so should be tried.

The diagrams describe visually what takes place. On a grid of twelve squares, a layer of glaze is placed and allowed to dry. Another layer of glaze of a different colour is placed across it. Where the two glazes intersect, a third colour will be apparent. The rest of the grid can now be completed with further layers of glaze.

As you can see, the permutations of this principle are

- 1. Thin glazes over thin opaque paint,
- 2. Thin glazes over thin transparent paint,
- 3. Thin glazes over thick paint,
- 4. Thick glazes over thin paint,
- 5. Light glazes over light glazes,

and so on and so on. All these variations are fascinating to try out and will produce some very exciting effects.

SCUMBLING

THE BRUSH MARK THAT combines some of the transparent qualities of a glaze with the exuberant spontaneity of impasto is a scumble. Scumbling is a somewhat vague term for applying a thin coating of colour vigorously brushed over the entire work or parts of it to soften the effect, but the real point of a scumble is to

SCUMBLING

Yellow and green are scumbled together but not blended.

Scumbles must be applied thinly so that previous applied layers show through.

create a free or broken brush mark which will allow the underpainting to show through to animate the colour and the surface at the same time.

Unlike a glaze, a scumble may be applied without any additional medium, and be either semi-transparent or opaque. Provided the underpainting is perfectly dry, the scumble may be dragged, scrubbed, dabbed or brushed in any fashion suitable for covering the entire work, or parts of it, quickly and spontaneously.

Scumbling is cruder than glazing, which implies carefully controlled transparent layers over selected parts of the work. Scumbling by its very nature is more hit-andmiss, and will delight those who go for textural effects, the particular transitions of broken brushwork and changes of mind, and will give a great deal of pleasure, both doing it and looking at it afterwards.

Scumbling, as its name seems to imply, breaks all the accepted rules for the methodical application of paint. Dry paint, hitherto discouraged as being bad for brushes and palette, is looked upon with favour. 'Dry paint' – a term artists often use when referring to applying a scumble – is a stiff rather than thick paint, so that when it is dragged across a surface – underpainting or canvas – it will leave a pleasant broken effect. Consequently instead of throwing away old, worn out brushes you find that they are ideal for the job of creating textural effects, used with dry paint, and with the scrubbing and rubbing that characterizes scumbling. And when these old brushes finally collapse, use a wad of tissue paper and dab with that to get the kind of effect you want.

Scumbling is particularly effective for dragging light paint over a dark ground and vice versa, or dragging one complementary colour over another. It is the perfect foil to flat, carefully done painting, and should be resorted to from time to time, not only for the experience of creating broken colour effects, but as an exercise in improvisation. As an experiment, try scumbling over any discarded paintings, and observe how a once-rejected work takes on a new life when scumbled over.

WHITING-OUT

despite its overlaying similarity, is the process I call 'whiting-out', or more accurately repriming, which is exactly what it is. The method I devised is ideally suited for acrylic, for it enables a painting to be continued indefinitely, or at least until you are satisfied with the result, without the repainted surface showing that it has been reworked in any way whatsoever.

Repriming is something that can be done without any difficulty with acrylic because of the quick drying and versatile textural qualities of rough or smooth, transparent or opaque. It cannot be done successfully with gouache or oil paint, because gouache picks up and oil paint is too thick and dries too slowly to make the operation worthwhile. It is worthwhile, if only for the following reason.

The recurring problem with paintings, illustrations and coloured drawings is that they frequently 'go wrong'.

SOME OTHER TECHNIQUES

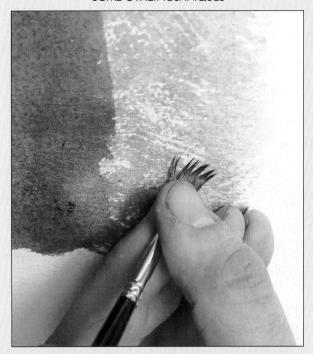

ABOVE Using a dry brush, pick up colour on the brush and move it lightly across the support. The dry brush

technique is used to blend or paint areas of finely broken colour.

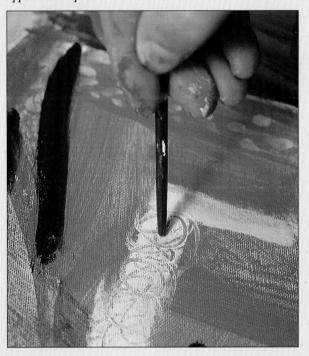

ABOVE Scratching. Any sharp tool can be used to etch lines and texture into acrylic paint

while it is still wet. Here a paint brush handle is being used.

MIXED MEDIA

1 TOP LEFT Wax resist. Wax crayon is applied to the support. Candles or any fatty, waxy material will do.

2 TOP RIGHT The next step is to paint acrylic over the crayon.

3 ABOVE The wax resists the paint, allowing a textured pattern to show through.

They don't, in fact, go wrong, they go astray, or outgrow their original intention. Nevertheless, however natural this feature may be, it can cause frustration, helplessness and despair when you are faced with it. To circumvent or anaesthetize the pain it can cause, whitingout or repriming will remove some of the sting. Moreover this can be repeated until the work adjusts itself and begins to flower again.

Only two conditions need be observed for this method

to work properly.

1. The surface of the paint must be smooth. Any impastos or texturing will interfere with the successful application of the new paint.

2. The white paint (or tinted paint) must be semitrans-

parent.

Whenever part of a painting needs correcting or changing, or loses its freshness, or the whole of the painting needs altering, dilute some white priming or tube white with water to make a thin semitransparent wash, and white-out the part or parts to be repainted. The density of the paint must be gauged by eye, just so long as the underpainting isn't completely blotted out.

Whiting-out can be done over an entire work. Repainting on still-discernible shapes can begin and whiting out can be done as often as necessary. With this method, the whiting-out is done with a painting knife. The white paint is gently spread over the work and allows the old work to show through better than if done with a brush, as it can be

spread really thin with the blade of a knife.

Another way of using this method is to use it not only as a corrective device but as an actual technique of building up a work from the start. The design or drawing is painted on unprimed white card (cardboard), or paper, with monochrome washes, and then whited-out over the entire work, letting the drawing or design show through.

As a variation on the white tone, the paint can be tinted with a colour. Experiment will tell whether a particular colour is suitable for whiting-out in this way, but umbers and ochres are good colours to begin with, rather than the primaries (though I have used blue tints with a great deal of success). The best advice I can give is to try them all. The permutations are many, as with most things connected with acrylic. The advantage of white as a reprimer is that it is ideal for transparent rather than opaque application of colour. The sparkle of transparent washes will be more easily retained with repriming with white. A tinted white would not be of much help here, and, though some of the effects may be quite startling, white is probably the safest tone to use if you want to be certain of the results.

WASHES

washes used in watercolour painting are perhaps the most difficult to control, and are probably one of the most difficult processes to master. Controlling them is a never-failing source of anxiety for some watercolourists, because if a wash goes wrong it cannot be put right, and so the work loses its point and purpose. Washes,

ABOVE To lay a flat wash, prepare plenty of paint. Use a wide, flat brush and run the strokes in one direction only. Each stroke should slightly overlap the one before.

even with acrylic, can be ruined, but because of the nature of the paint itself, you can use whiting-out and put it right again.

Although acrylic can be used like watercolour, it must be clearly understood that acrylic washes function differently from watercolour washes. The main difference is the paint composition itself, for though the pigments may be identical, the binders are not. Watercolours can be diluted so thinly that they have hardly any body at all. The gum binders are capable of holding the pigments together despite overthinning. Acrylic, on the other hand, has a binder that imparts weight and substance to the paint which must be considered, especially when overthinning the paint, and it cannot be ignored without breaking down its inherent qualities. A useful measure to adopt is always

to add a good few drops of the acrylic medium when diluting acrylic paint for washes, as a precaution. It will keep the wash from looking thin and lifeless, and will add a sparkle that ordinary watercolour sometimes lacks.

Acrylic washes can be varied in a number of ways not unlike watercolour, but happily because the particular characteristic of the medium is to impart bulk to a paint once thinned, it is easier to manage. A simple trial with watercolour will prove this quite conclusively. Watercolour occasionally behaves in a capricious way that some painters find almost impossible to control. By comparison, acrylic, by the very nature of its medium, is less temperamental, always provided that additional medium is reintroduced into the wash and can be manipulated by even the most inexperienced with relatively little skill.

There is perhaps only one rule to observe, that like pure watercolour, once a wash is applied, leave it alone.

Acrylic washes can be formed by:

- 1. flooding one wash into another
- 2. adding fresh colour to an already applied wash
- 3. adding colour to moistened paper
- 4. gradated tones from dark to light
- 5. flat
- 6. animated by brushstrokes
- 7. overlay
- 8. allowing the surface to play its part
- 9. allowing the wash to run freely, without any control whatsoever.

The following experiments should give a great deal of experience. They should be tried on paper, card (cardboard) and even canvas, with and without priming. Vary them by using both smooth and textured surfaces. The addition of the water tension breaker or wetting agent will ensure that washes will flow and absorb well on to the support. It is important to experiment in the following ways occasionally, so that you become familiar with the effect each method has.

Sables are traditionally more suitably for washes than hog's-hair brushes, and should be as large as possible (number 7 or 8). Hog's-hair may be tried but are less flexible for gradating and spreading a wash smoothly. As long as you recognize this, they can be tried as a means for creating variations of the basic wash technique.

EXPERIMENT 1 - FLAT WASH

- ► Squeeze out ½ in/1 cm of paint into a clean container.
- Add water to dilute, mix well to make sure that there are no lumps of undissolved paint as this will ruin a wash.
- ★ Add some acrylic medium last about a teaspoon will do.
- ➡ With a large brush spread the wash down the paper or card (cardboard), working from the top, to make a flat wash. Whatever happens, do not touch the wash once it has been applied. Let the colour find its own level.
- The application can be carried out upright or on the flat. If upright the wash will run down rather quickly.

EXPERIMENT 2 - GRADATED TONES

EXACTLY THE SAME AS Experiment 1, only in this experiment instead of painting the wash completely in one colour, halfway through continue with clean water only and let the colour blend into it. This is easy to do with pure acrylic colour, provided there is plenty of medium in the wash, and water tension breaker (wetting agent) in the water.

ABOVE Experiment 2. To achieve a gradated effect, work quickly, adding water to the paint in increasing quantities with each successive band of colour.

ABOVE Experiment 4. To produce this wet-in-wet, the artist began with a graded wash of cobalt blue and added a graded wash of lemon yellow.

ABOVE Experiment 3. Single colour wet-in-wet wash, made by covering the support with a layer

of water and allowing a wash of colour to flood into it.

EXPERIMENT 3 – MOISTENED PAPER

FIRST COVER THE PAPER or card (cardboard) completely with water. Then, before it has properly dried, flood a wash into it as above.

EXPERIMENT 4 - ADDING COLOUR

THIS EXPERIMENT CAN COMBINE any or all of Experiments 2 and 3. Proceed as above, and before the colour has dried flood another colour into the wet surface. Usually known as wet-in-wet.

OVERLAY

ABOVE Lay the palest colours first, so that the light reflects off the white paper.

ABOVE It is vital to allow one colour to dry completely before applying the next one.

ABOVE The artist applies a thin wash of Hooker's green over the first colour. Where the two washes cross, a third hue is produced.

EXPERIMENT 5 - OVERLAY

THIS IS EXACTLY LIKE glazing. Proceed as above, but let the colour dry out thoroughly. Then apply further washes over the dried paint. In pure watercolour, the paint may pick up, but with acrylic this can never happen.

BELOW The use of animated strokes with a hog's-hair brush produces a very active texture.

EXPERIMENT 6 – ANIMATED BRUSHSTROKES

FOR THIS EXPERIMENT, USE an ample amount of acrylic medium with the paint and, when well mixed, the wash can be applied, letting the brush play its part by animating the wash with brushstrokes. Hog's-hairs can be used for this experiment with profit.

Washes are one kind of effect that looks well without under- or overpainting, hence their popularity for immediate statements, especially for figurative work like landscape painting where, being outdoors in all kinds of weather, speed and spontaneity are vital. Immediacy and fluency, however, are easily lost if these washes are overworked, which may be the reason why flooding and merging of one colour into another is not really possible with opaque or more solid paint which depend on their effects by overpainting in layers.

Washes can, of course be overpainted, which, as has been pointed out, is similar to glazing, but unlike glazing – which can be carried out on all kinds of surfaces, underpaintings and impastos – overpainting washes is always better on a white surface. This ensures the retention of the transparency and sparkle so typical of watercolour.

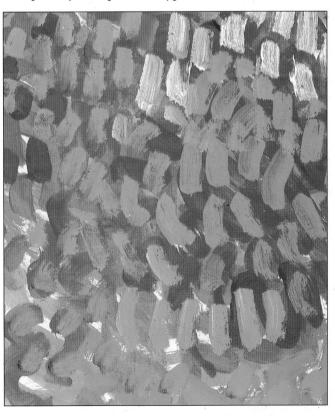

ABOVE Hatching using ink. By varying the density of the lines, a wide variety of tones is achieved. Freely drawn lines look more lively than perfectly straight, mechanical lines.

RIGHT An old, splayed brush was used to create this slightly rough, hatched texture in acrylic. The underlying colour glows through the overpainting to great effect.

HATCHING

HATCHING IS A VERY old and basic means for gradating tones on white paper with something as dense and impenetrable as pen and ink. Gradating tones with a pencil is much easier, as most of us will have experienced before now, and painted washes are perhaps one of the simplest and best means of achieving it in the most subtle and effective way. When painting expanded from simple washes to the more complex paints like gouache, tempera and fresco, the technique that was adopted was that of hatching, which reached its full development in the 14th and 15th centuries, before the introduction of oil paint rendered it obsolete. Oil paint could render gradated tones so much more realistically than hatching with tempera - but at a cost. The qualities of texture and colour that hatching brought were sorely missed, until renewed interest in water-based painting revived the method. Acrylic, being one of these, is ideally suited to hatching.

Hatching consists of the criss-crossing of hundreds of small lines over each other to produce a rich variegated tone. The more these fine lines are hatched the more dense the tone becomes. Many drawings by the old masters were done this way, and so inevitably became the basis of the way they painted. When one examines a 14th- or 15th-century tempera panel, it will be seen to be made up of hundreds of tiny strokes of colour, sometimes going around the forms, to accentuate the solidity, sometimes across the forms to show the play of light and dark.

In painting with a hatching technique, the open network

of lines means that not only are the tones gradated, but the underpainting can filter through as well, thus enhancing both tone and colour at the same time – another reason why, perhaps, tempera painting has a brilliance that oil painting seems to lack over the centuries.

Hatching with acrylic will involve small sable brushes (0, 00 or 1) as well as thin paint, which can be either transparent or opaque, or even a mixture of both. But it must not be too thick, or the hatching will lose its delicacy, and be more difficult to manipulate.

Hatching is a delicate and painstaking operation, but with patience can produce remarkable and effective results that are well worth the trouble they involve.

EXPERIMENT IN HATCHING

DRAW A SMALL GRID of 1-in/2.5-cm squares. About four will suffice. Try filling them with a variety of hatching as follows:

- 1. cross hatching with one colour,
- 2. cross hatching from dark to light,
- 3. cross hatching from the centre outwards,
- 4. cross hatching from the outside inwards.

Vary the hatching with both transparent and opaque lines, and short and long, thick and thin strokes, to create as much variety of texture as possible.

STIPPLING

STIPPLING IS SOMEWHAT LIKE hatching in that it is the building up of tone with hundreds of tiny marks. But with hatching, the marks are strokes of the brush – long, short, thin or thick – whereas with stippling, dabs are made with the point or end of the brush.

If sables are used for stippling, it is wiser to use the older, more worn out brushes, as stippling can be very hard on them unless used with a very gentle kind of stipple, which is not easy to do as the dabbing action is a forceful one. As with hatching, the process is a painstaking one. The overpainting of hundreds of tiny dots one on the other gives a pleasing effect, and the tonal gradations are even more delicate than with hatching. However it is unnecessary to cover the work completely with stippling. You can confine it to the parts with a more telling effect.

Georges Seurat, the pointillist painter, who took Impressionism one stage further, stippled his tones and tints of pure colour, without mixing them, throughout the painting. The intention was to let the eye do the mixing. Unfortunately his paintings were not carried out in acrylic, as they hadn't been invented at that time – but there is no reason why acrylics shouldn't be tried in this manner, provided the stippling has some kind of colour system as a foundation for the design, or that the stippling is consistent in its marks throughout the work.

Experiment with stippling in the same way as hatching. The paint can be thicker than with hatching, if desired, and stippling can also be carried out with materials other than brushes: sponges, wads of paper, toothbrushes, even fingertips will do as an alternative.

LEFT Stippling with a brush is carried out by holding the brush at right angles to the painting surface, and repeatedly touching the tip to the surface.

BELOW The effect is an area of colours that appears lighter and brighter than the equivalent colour applied in a flat wash.

As with hatching, the aim should be to keep the dabs as separate as possible to achieve the maximum effect. The dabs should be as crisp as possible, though piled up over each other; they should not smear or smudge into each other. As with hatching, allow any underpainting to filter through if possible.

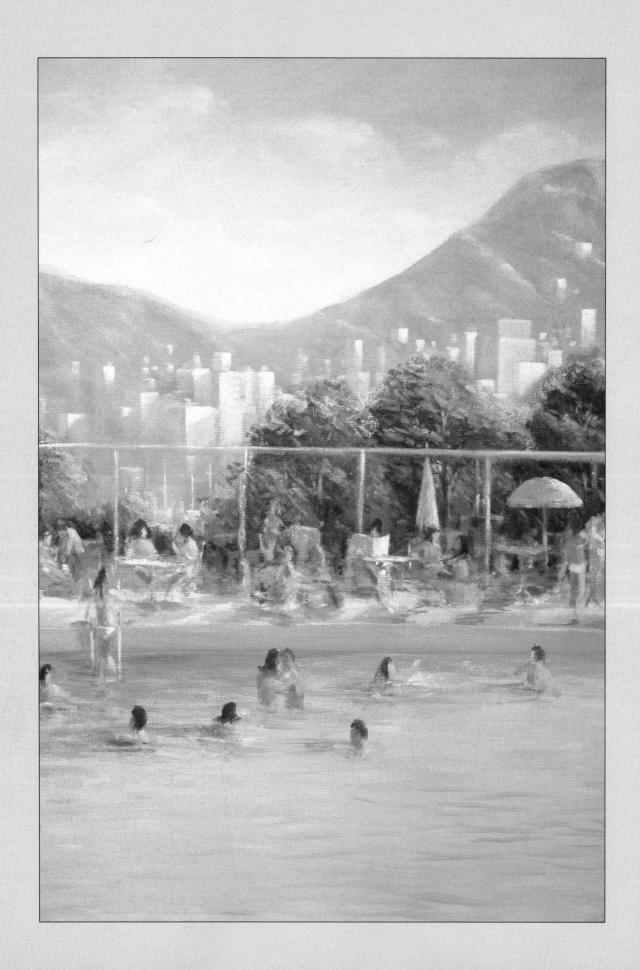

CHAPTER FOUR

THE PROJECTS

PAINTING IS about looking and seeing and translating what you see in the three-dimensional world around you, through selective and imaginative processes, into pictures. Visual source material for your paintings is everywhere around you, on a table, in your room, through a window or even in your mirror. Look at your everyday surroundings with new eyes for a subject and you will find plenty of inspiration.

SWIMMERS IN HONG KONG

waterside pictures are popular subjects for artists, not only because they conjure up holidays, but also because they offer at least three quite separate elements to work on, the water, the landscape and the sky. This picture was painted essentially as a landscape and then brought alive by the addition of figures, buildings and other points of human interest.

The artist used the photographs as starting points only,

identifying major features in them, particularly the vegetation, the mountains and the water, before creating his own imaginary landscape. The form of the trees will be treated with adjacent areas of light and shadow while the hazy distant mountains will be emphasized by the use of colours, mainly white and blue.

The almost impressionistic finish was achieved by the use of soft, carefully directed brushstrokes and reinforces the relaxed holiday atmosphere which is the central theme of the painting.

- 1 Two photographs of the city provide the artist with basic ideas for his picture. He will 'sandwich' these with other images in his own mind to compose the scene he wishes to paint.
- 2 The artist fills the water in primarily with phthalocyanine blue and titanium white which effectively reflect the colours of the sky and background landscape. The trees are strengthened with Hooker's green and the hills given more weight and bulk with medium magenta.

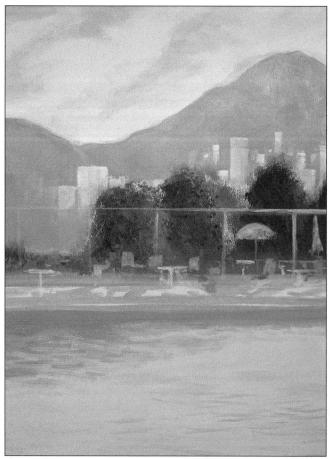

3

MATERIALS USED

SUPPORT

■ prepared, acrylic-primed canvas board measuring 36 × 25in/92 × 64cm

BRUSHES

- Nos. 2 and 5 round bristle and synthetic
- Nos. 2, 4, 6 and 11 flat bristle and synthetic

COLOURS

- Hooker's green
- ivory black
- phthalocyanine green
- medium magenta
- I titanium white
- cobalt blue
- phthalocyanine blue
- raw sienna

- 4 Detail in the foreground is now developed, with the correct emphasis on form retained, in keeping with the overall picture.
- 5 Although the figures are very much in the foreground detail would have been impossible here, as the perspective of the composition, with mountains and tall skyscrapers in the background, requires that they be fairly small.

6 The trees are darkened with Hooker's green and highlighted with phthalocyanine green, again in broad brushstrokes.

7 The skyscrapers are blocked in with strong simple brushstrokes and are set off against each other with varying mixtures of blues and white.

8 The figures have plenty of movement and definition as a result of the careful combination of different colours and tones.

9 The finished painting is very successful and owes much of its success to the way in which the brushstrokes were applied to the canvas. The texture of the canvas itself has also been used to advantage to give depth to the picture and to convey the steamy atmosphere characteristic of Hong Kong.

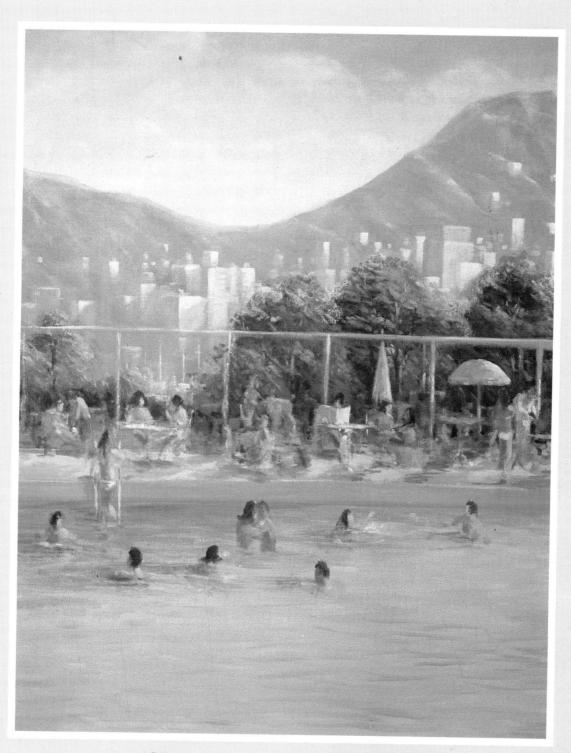

Swimmers in Hong Kong

YOUNG MAN IN A STRIPED SHIRT

THIS IS EFFECTIVELY a rapidly-done sketch on a large scale. It could have been taken much further, but the bold and quick brushstrokes, and the scale, allow it to work as a vigorous and lively piece already. The spontaneous use of colour, to catch the most significant elements in the composition, was more important than filling in all the finer details.

Try painting quickly as it is a useful discipline that will teach you to structure and compose the whole picture and stop you from becoming too distracted by less important minor details.

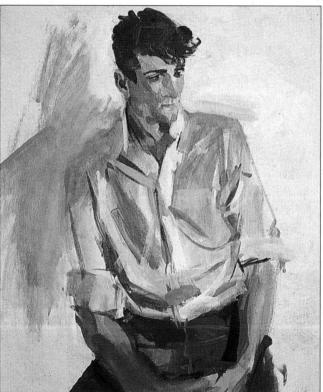

MATERIALS USED

SUPPORT

■ prepared board, measuring 24 × 20in/ 60 × 50cm

BRUSHES

- Nos 6 and 10 round bristle
- No. 4 flat bristle

OTHER MATERIALS
Oil Pastel
Soft Pastel
Pencil

COLOURS

- ivory black
- titanium white
- chrome oxide
- naphthol red
- yellow ochre
- cerulean blue.

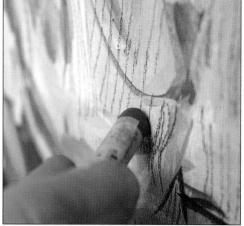

.3

Young Man in a Striped Shirt

- 1 The artist will attempt to work as quickly as possible as the model is sitting up fairly straight, quite a tiring position to maintain for any length of time.
- 2 The artist paints directly onto the support without bothering to make any rough drawing or outline sketch. The shadow tones of the head and torso are blocked in first.
- 3 The main blocks of colour, the hair, the trousers, the arms and the face are built up quickly with relaxed brushstrokes, and then the shirt with a mixture of all the colours.
- 4 A soft pastel is used to give extra life and colour to the flesh tones; the texture of the pastel allows the artist to obtain firm edge on the arms and hands.
- 5 The combination of different mediums such as soft pastel, oil pastel, and pencil injects variety of texture into the picture.
- 6 The finished picture has a delightful informal sketch-like quality and shows just what can be achieved by working quickly and confidently without dwelling too much on relatively unimportant superficial details.

FOOD ON THE FARM

STILL LIFE is one of the simplest and most accessible of painting subjects. Unlike landscapes, for example, still lifes give you the opportunity to choose and arrange objects in any way you like. There is no need to stage an elaborate arrangement of objects, either, especially if time is pressing. In this painting the artist has chosen as his subject the remains of a simple rustic meal left on the table. An arrangement such as this can have great appeal, because somehow it captures a moment in time: it isn't merely a collection of lifeless objects.

In keeping with the earthy simplicity of the subject, the artist used a painting knife to give a rough-textured surface to the painting. Acrylic paint has a thick, buttery consistency, and can be 'sculpted' to create interesting surface effects that lend character to the painting. A knife can not only pile on thick paint successfully, it can also be used for scraping out unwanted passages. You must work quickly, though, due to the fast drying time of acrylic paint.

Another interesting point about this picture is that it was painted, not onto a white support, but over another painting beneath. This was an unfinished painting which the artist had rejected. Because the original work had not reached an advanced stage it was an easy matter to overpaint it, especially since acrylics have such good covering power. Rather than paint out the original image, however, the artist chose to work directly onto it, so that faint lines and shapes showed through the blocks of colour as the new work progressed. This method has one great advantage: it alleviates the problem of facing a glaring white canvas and being afraid of 'spoiling' it. Having shapes and colours already there on the canvas is much less inhibiting.

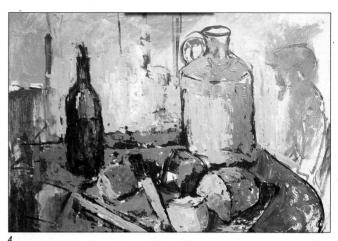

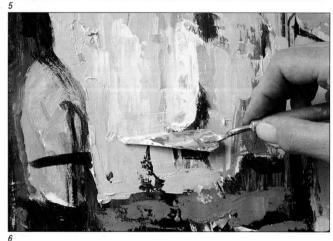

- 1 Simple and uncontrived, this still life group nevertheless contains an interesting variety of shapes and textures.
- 2 Working over an old painting, the artist begins by blocking in the main colour areas with loose brushstrokes.
- 3 The forms of the still life are drawn in with a brush and diluted

- paint. Parts of the old painting still show through in places.
- 4 Now the image is beginning to take shape.
- 5 This detail shows the various textures that can be achieved with a painting knife, from the smoothness of a knife blade to the rough, stippled texture of a crumbled brown loaf.

6 The paint is used thickly, often being mixed directly on the canvas instead of on the palette. Note the rough-hewn texture created by the knife.

7 This close-up of the earthenware jar shows how the artist has used the painting knife to partially mix the colours and build up a textured impasto.

8 The finished painting shows how bold and direct a knife painting can be. The artist has deliberately left the paint surface rough and unfinished, preserving a lively spontaneity that is entirely in keeping with the rustic simplicity of the subject.

MATERIALS USED

SUPPORT

■ prepared board primed with acrylic, measuring 24×20in/60×50cm

BRUSHES

- No. 7 flat hog's-hair
- Nos. 2, 4 and 6 round
- Nos. 3 and 5 synthetic fibre

COLOURS

- burnt umber
- yellow ochre
- acadmium red medium
- ultramarine
- ivory black
- titanium white

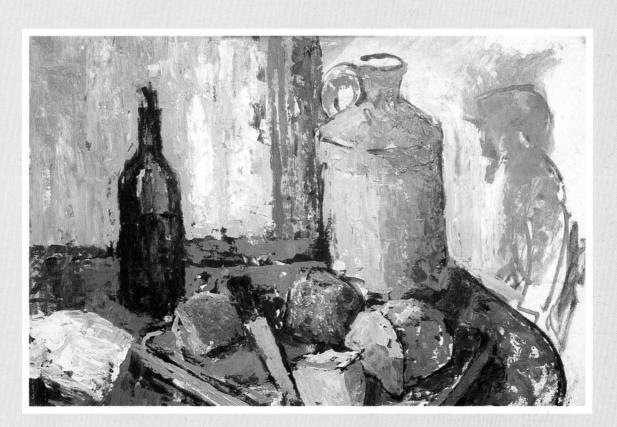

Food on the Farm

STILL LIFE WITH BOTTLE, FRUITS AND VEGETABLES

FOR THIS STILL LIFE PAINTING, the artist has used an intriguing combination of a modern medium – acrylic - and a traditional oil painting technique dating back to the days of the Old Masters: namely, that of developing a detailed underpainting over which transparent glazes of colour are applied, layer upon layer, to achieve a translucent and shimmering surface.

Hundreds of years later, the miraculous effects achieved by the Masters still fill us with admiration and awe. However, the technique which they used was a slow and laborious one, since each layer of paint had to be left for several days to dry out before the next one could be applied. If a layer of oil paint is applied over an underlayer that is not completely dry, cracking ensues and the painting can be ruined in a very short time.

With the advent of acrylic paints in the 1950s, this problem was at last solved. Like oil paint, acrylics can be used thickly or in thin washes; but, unlike oils, they dry very quickly and repeated layers of colour can be built up without any danger of cracking.

Acrylics, then, can achieve all that oil paint can, but much more quickly and with less risk.

Following the traditional method, the artist has here worked on a tinted ground, painting from dark to light with very thin layers of colour. Before starting to paint, the artist drew a detailed sketch of the still life. This, coupled with the quick-drying properties of the acrylic paints, allowed him to complete the painting rapidly once begun, as all preliminary planning and decision-making had been finished beforehand.

1 For this still life, the artist chose objects whose soft colours and shiny textures would lend themselves well to the glazing technique.

2 The first step is to tone the canvas with a thin wash of burnt umber, well diluted with water. This sets the tone for the whole painting, and softens the stark white of the canvas. The still life objects are then indicated with thin black paint and a No.2 brush.

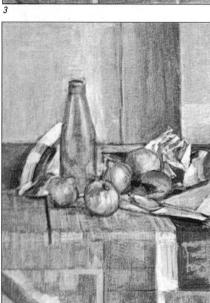

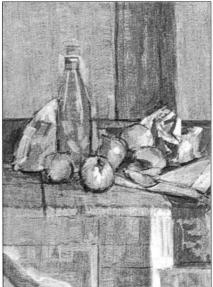

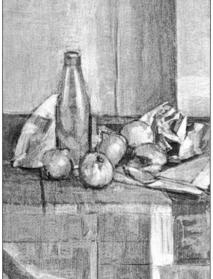

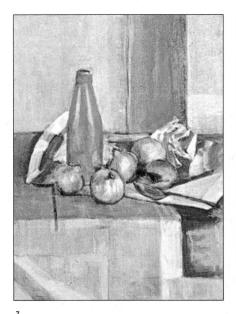

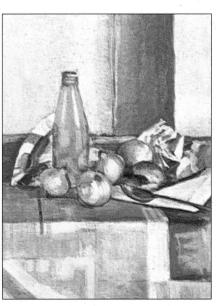

8

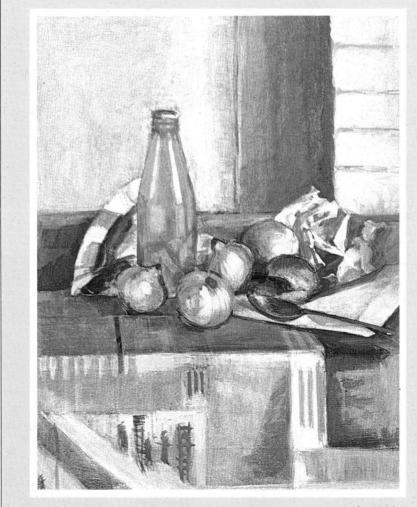

Still Life With Bottle, Fruits and Vegetables

- 3 Next the artist blocks in the lightest areas of the painting with thin white paint and a No.10 brush, blending them with a rag.
- 4 Working over the entire surface, the artist blocks in the strong highlight areas with a No.4 brush and pure white paint, used a little more thickly this time.
- 5 With a No.2 sable brush, the artist redraws the outlines of the subject in black thinned with water.
- 6 A dilute mixture of cadmium yellow and white is used for the onions. Then the shadow areas around the onions and the table are strengthened with thin washes of ivory black.
- 7 A cool tone of white and yellow ochre is now applied with a No.10 brush and worked well into the surface. Note how the warm underlayer still shines through.
- 8 With a fine brush and white paint, the artist develops the highlights and reflections in the bottle and the onions.
- 9 The completed painting has all the vigour of an alla prima painting, yet is also has a subtlety and delicacy. The dark underpainting ensures a unity in the painting as it permeates all subsequent layers of paint giving an overall warmth.

MATERIALS USED

SUPPORT

■ prepared canvas board measuring 16×20in/40×50cm

BRUSHES

■ Nos. 2, 4 and 10 sable round oil brushes

COLOURS

- ivory black
- burnt umber
- cadmium yellow light
- yellow ochre
- titanium white

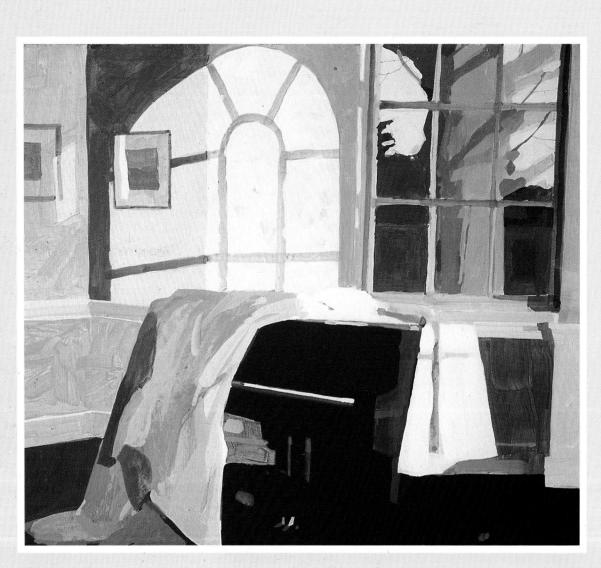

Interior

YOU DON'T NEED TO TRAVEL FAR and wide in order to find a suitable subject to paint; often the most interesting pictures are those which feature familiar objects and ordinary places. An interior scene, for example – perhaps the very room you are sitting in now – can provide an endless source of inspiration for the creative artist.

As with still lifes, you can arrange the objects in an interior, and also control the lighting, to express a particular mood or to make a personal statement. In this painting, for example, the artist has created a spare, almost abstract

composition which captures the melancholy mood of a large, bare room on a cold winter's day. Through the window we catch a glimpse of the grey, wintry landscape beyond. The shadow of the window slants across the cold, empty wall. And in the corner stands a grand piano, half-hidden by a shroud-like dust sheet. Altogether, an atmospheric and thought-provoking composition.

To capture the mood of the scene, it was essential to work quickly before the light changed, and this is where the fast-drying properties of acrylics saved the day. The artist worked with a limited palette of neutral colours, and applied the paint directly onto the canvas with broad, flat washes.

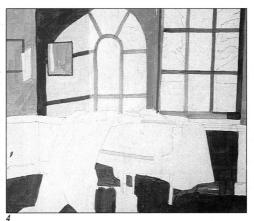

3 Using a No. 4 flat brush, the artist paints in the lines of the window frame, and its shadow cast on the wall, with raw sienna.

4 Now the dark tones of the foreground are blocked in with burnt umber darkened with black.

5 The artist paints 'negatively', working the dark tones around the white shape of the dust sheet covering the piano. The folds in the dust sheet are indicated with strokes of burnt umber.

6 The shadows on the background wall and on the dust sheet are now built up using Payne's grey, cobalt blue, yellow ochre and titanium white.

7 Finally, the scene outside the window is painted in, using Payne's grey, Mars black, burnt umber and titanium white. Subtle, neutral colours have been used throughout, and this contributes to the quiet, introspective mood of the painting.

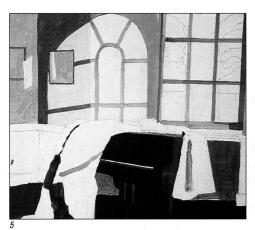

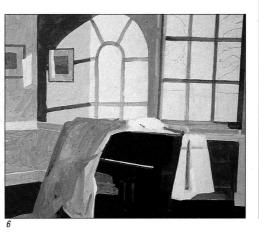

MATERIALS USED

SUPPORT

■ Gesso-primed hardboard measuring 10×12in/ 25×30cm

BRUSHES

■ Nos. 4 and 7 flat synthetic hair

COLOURS

- raw sienna
- yellow ochre
- Payne's grey
- Mars black
- titanium white
- burnt umber
- cobalt blue

IRISES IN A GREEN VASE

A STILL LIFE SUBJECT such as a vase of flowers may seem like a simple one, but it is nevertheless very important to plan the composition carefully in order to create a pleasing image.

Because this vase of irises was such a symmetrical shape, it could have produced a stiff, boring picture. But the artist has avoided this problem by lighting the subject from one side to create interesting elongated shadows. He also arranged the subject on the canvas in an interesting way. Rather than place the vase of flowers in the centre of the canvas, which would have been the most obvious solution, he chose to place it off-centre, where it interacts with the rectangles created by the shelf and the side of an alcove.

Part of the appeal of this painting is in its crisp, clean edges. The artist used masking tape as a stencil in order to achieve the clear-cut characteristics of the highlights and shadows on the vase and the leaves.

In painting the subtle colours of the irises, the artist has used oil paint over an acrylic base. Because oil paint is slow-drying, it can be blended to create soft gradations of tone and colour – something which cannot be done with acrylics because they dry so fast. Do remember, however, that oil paint can be used over acrylic, but not vice versa. Acrylic paint will not adhere to an underlayer of oil paint, and starts to crack off in a very short time.

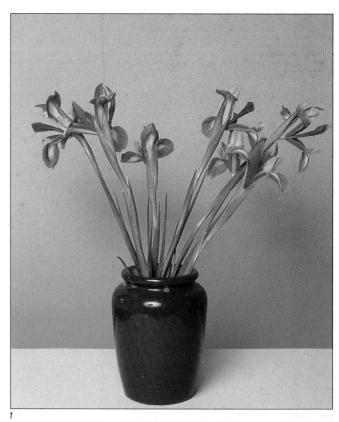

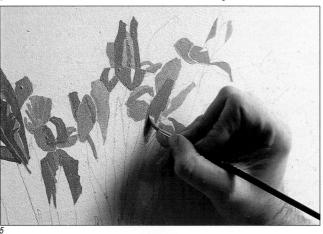

- 1 The tall, elegant irises are placed against a cool, grey background which complements the cold blues and greens in the arrangement.
- 2 The artist places the subject offcentre, to create an interesting visual tension with the surrounding space.
- 3 Because the artist intends to build up the picture systematically, the drawing is detailed enough to act as an accurate guide to the placement of each area of tone and colour.

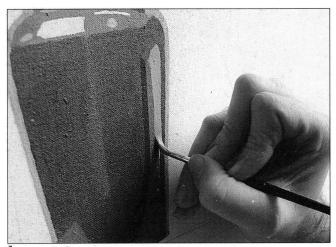

- 4 The artist begins by painting the flowers. A purple-blue is mixed from ultramarine, white, black and a little crimson.
- 5 The irises are developed from light to dark, each tone being completed in flat patches of colour. More white is added to the lighter areas.
- 6 The leaves are painted in three tones of green mixed from chromium oxide, ultramarine and white. Touches of cadmium yellow pale are added to the centres of the irises.

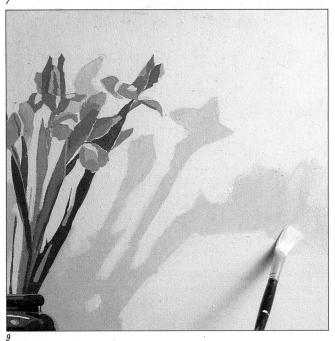

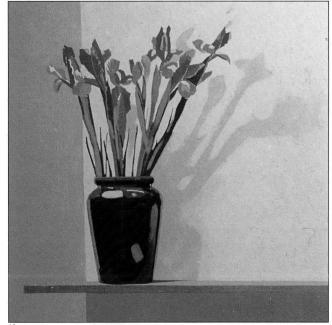

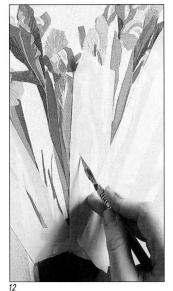

- 7 The vase is painted with a mixture of emerald, chromium oxide and raw umber. For the shiny highlights, the artist uses the basic vase colour with added white and yellow ochre.
- 8 The straight edge of the background shadow on the left is achieved with the aid of a ruler. The shadow area is then painted with a mixture of Payne's grey and ultramarine.
- 9 The rest of the background is a very pale grey, made from white with touches of black and ultramarine. A slightly darker tone of grey is used for the shadows of the flowers, which are softened and blurred at the edges.

- 10 The shelf is painted next, using a mixture of raw sienna and white. The dark shadow is mixed from black, white, ultramarine and raw umber.
- 11 The final details of the flowers are completed in oil paint because the colour is slow-drying and easier to manipulate. The darks in the flowers are mixed from ultramarine, alizarin crimson and a touch of white.
- 12 When the paint is dry, the artist begins work on the crisp shapes of light and shadow on the leaves. He uses masking tape as a stencil, sticking it firmly to the canvas so that no paint can seep under the edges.

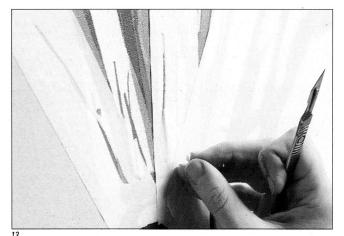

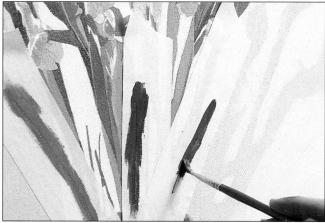

13 The delicate shapes to be painted are cut out with a sharp scalpel or blade, being careful not to cut the canvas. These shapes are then peeled away.

14 Thick oil paint is used to paint the shapes which have been cut out of the stencils.

15 When the paint is thoroughly dry, the masking tape is gently peeled off the canvas, revealing the sharp, clean lines of colour on the leaves.

16 Because the style of the picture is so graphic, the artist decides to add texture to the flat background colour using a soft pencil.

17 The finished painting has a pleasing sense of harmony and balance. The square canvas is divided into three geometric shapes, whose straight lines provide a contrasting setting for the organic flower forms and their soft shadows cast upon the wall behind. The loose pencil strokes are in complete contrast to the tight composition and precise shapes.

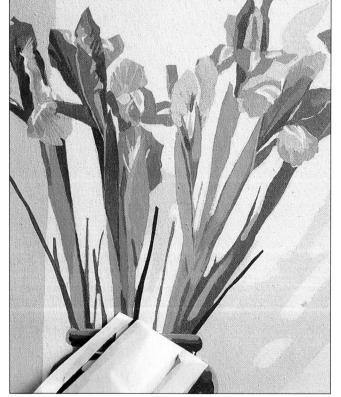

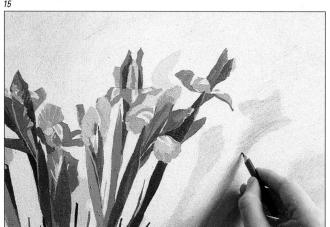

MATERIALS USED

SUPPORT

■ stretched canvas treated with acrylic primer, measuring 30×30in/76×76cm

BRUSHES

- No. 3 bristle
- No. 4 sable

OTHER EQUIPMENT

- masking tape
- a sharp scalpel
- a B pencil

ACRYLIC COLOURS

- napthol crimson
- ivory black
- cadmium yellow pale
- emerald green
- chromium oxide
- raw umber
- yellow oxide
- yellow ochre
- ultramarine blue
- cobalt blue
- titanium white

OIL COLOURS

- ultramarine blue
- alizarin c mson
- sap green
- chrome green
- ivory black
- yellow ochre
- cadmium yellow
- raw umber
- titanium white

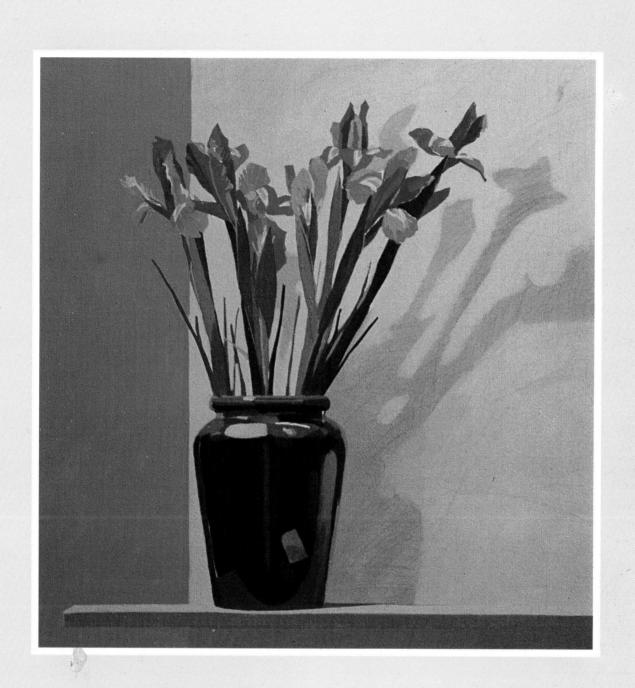

Inises in a green vase

LANDSCAPE WITH SHED

ACRYLIC IS WITHOUT DOUBT one of the most versatile painting mediums to date. This landscape demonstrates how techniques and methods borrowed from other mediums can be effectively and harmoniously combined in one picture. For example, the artist has used a sheet of stretched heavy white paper, as one would with watercolour, but has begun the painting using the traditional oil technique of underpainting.

The artist continued to develop the picture using both watercolour and oil techniques. For example, thick paint has been scumbled and dragged in places, in the manner of oil paint. In other areas, the wash, a traditional watercolour technique, is used to exploit the underpainting and create a light, subtle tone which complements the heavier, opaque passages. All of which goes to show that there are few rules in acrylic painting, and that a wide range of expressive techniques can be used to get the most out of your subject.

MATERIALS USED

SUPPORT

■ stretched heavy white drawing paper measuring 20×23in/50×58cm

BRUSHES

■ Nos. 4 and 6 synthetic fibre

COLOURS

- alizarin crimson
- ivory black
- burnt sienna
- cadmium red medium
- cerulean blue
- chrome green
- yellow ochre
- titanium white

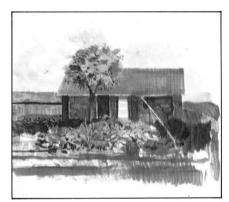

2

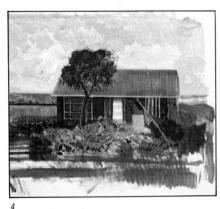

5

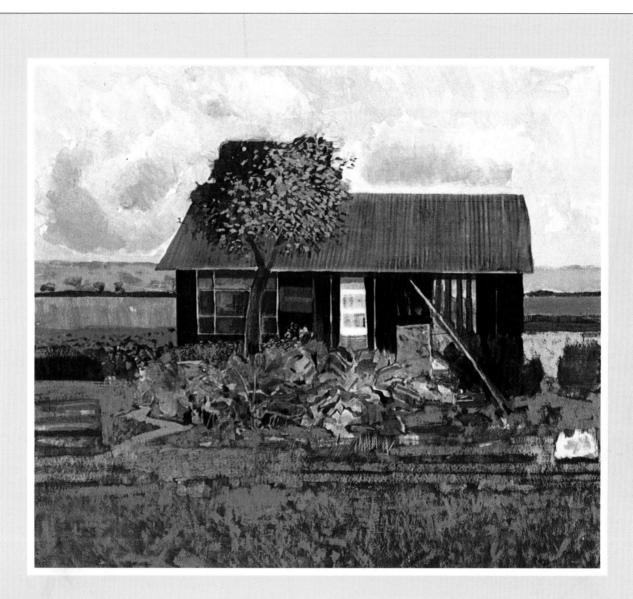

Landscape with shed

- 1 Working on stretched and dampened paper, the artist begins by lightly sketching in the subject with a pencil. Then he starts to block in the shed with washes of alizarin crimson and burnt sienna.
- 2 The main shapes and outlines are further developed with very wet washes of burnt sienna. In places the tip of the brush is used to 'draw' the outlines.
- 3 The roof colour is put in next, using a mixture of burnt sienna and cadmium red. The

- darker grass and shrub colours are flicked in with pure chrome green.
- 4 Now the painting is taking shape. A thin wash of cerulean blue is used for the sky, with pale scumbles of alizarin crimson for the clouds. The light and dark tones of the foliage are developed with mixtures of chrome green and white.
- 5 A light green tone is used for the highlights in the foliage and grass. A wash of burnt sienna is brushed into the foreground area.
- 6 The artist now covers the foreground with a light green tone of dryish consistency, allowing the brown underpainting to show through. With a No.4 synthetic brush, the artist works over the painting putting in the final details, such as the tiles on the roof. Notice how the artist weaves warm reds and cool greens through the painting to create a vibrant colour harmony.

BOATS ON THE BEACH

OFTEN THE MOST DIFFICULT STAGE in the painting process is that of actually getting started. A sheet of stark white canvas can be quite intimidating - one is nervous of applying the first brushstroke for fear of making a mistake.

The application of a toned ground can help by providing a more sympathetic colour upon which to begin work. Traditionally used in oil painting, a toned ground is a thin wash of colour which is brushed over the entire canvas prior to commencing the painting.

A toned ground serves two purposes: firstly, it provides a more neutral colour than that of the canvas itself and makes it easier to judge the relative intensity of the colour mixtures which are applied over it. Secondly, if the toned ground is allowed to show through the overpainting in places it acts as a harmonizing element, tying all the other colours in the painting together.

Traditionally, a toned ground is a neutral or earth colour, or it can give a generalized idea of the overall colour scheme of the subject. In this painting, for example, the artist uses a warm, earthy tone which harmonizes with the colours laid over it.

TONED GROUND

1 Generally, the colour for a toned ground is mixed on the palette and applied to the support with smooth, even strokes. Here, however, the artist begins by applying the colour in loose strokes which will be blended

together on the canvas. Cadmium red, yellow, ochre and white, well diluted with water, are freely and loosely painted over the white surface.

2 When the canvas is well covered, and thoroughly dry, a thin wash of white paint is scumbled over it. The result is a medium-to-light toned surface in which the brushstrokes are

only partially blended. The colours blend in the viewer's eye, however, and the effect is more vibrant than a flat wash of colour mixed on the

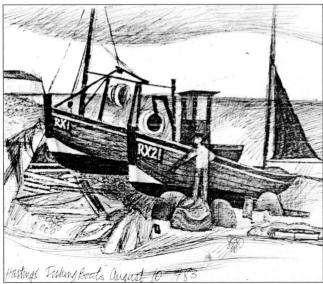

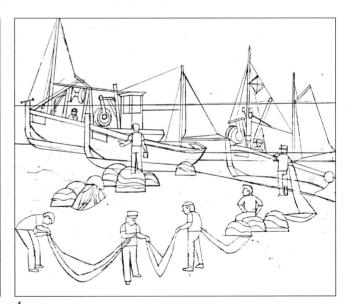

5
5 With the toned ground now completely dry, the artist blocks in the sky area with a very pale wash of white and ultramarine, toned down with a touch of burnt umber. The foreground is brushed in with burnt umber, yellow ochre and

white.

6 The artist now adjusts the tones in the scene, darkening the sea with ultramarine and lightening the foreground with pale washes of white, yellow ochre and ultramarine.

4 A key drawing is made from the sketches, which will be traced onto the painting at a later stage.

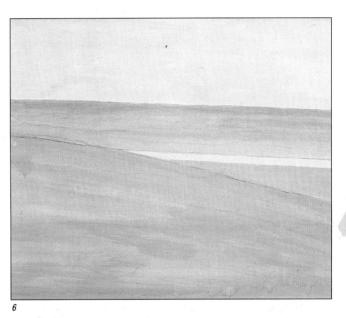

7 The line of surf is painted with pure white. The key line drawing is traced onto the painting and outlined in burnt umber with the tip of a No. 2 sable brush.

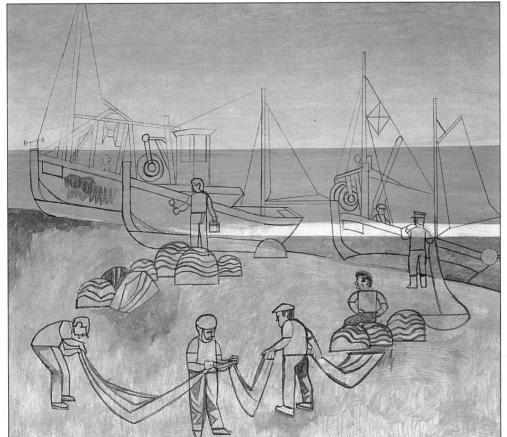

MATERIALS USED

SUPPORT

■ prepared board primed with acrylic, measuring 24×20in/60×50cm

BRUSHES

- No. 7 flat hog's hair
- Nos. 2, 4 and 6 round sable
- Nos. 3 and 5 synthetic fibre

COLOURS

- burnt umber
- yellow ochre
- cadmium red medium
- ultramarine
- ivory black
- titanium white

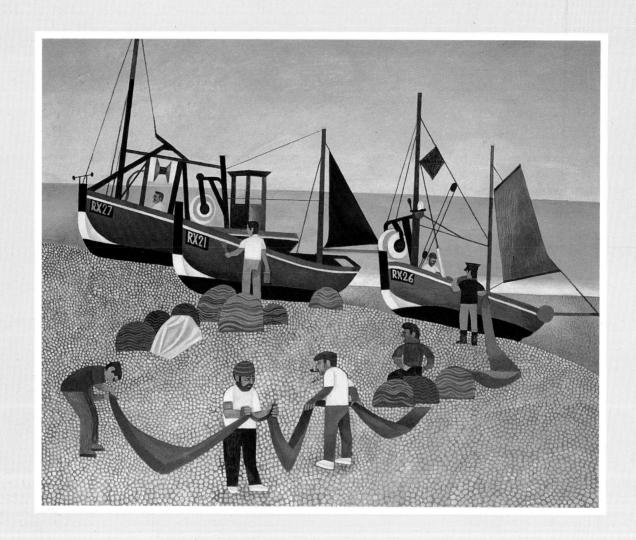

Boats on a beach

8

8 The outlines of the figures and the boats are filled in with colour, using burnt umber, ivory black, titanium white and ultramarine. Stippled dots of yellow ochre mixed with white are used to create the texture of shingle on the foreshore. The charm of this picture lies in its simple, 'naive' style. The fishing boats and the figures are composed and arranged in such a way as to lead the viewer's eye from foreground to background.

A CORNFIELD IN SUMMER

ACRYLIC PAINT is extremely versatile, having many of the advantages of other mediums but few of the disadvantages. In this landscape composition the artist has combined a number of different painting techniques, from thin washes and glazes to thick impasto. Since acrylic paint dries in minutes, the artist was able to build up succeeding layers of paint very rapidly. In addition, the efficient covering power of acrylic means that light colours can be painted over dark ones without any danger of the underlying colour showing through. This gives the artist considerable freedom to experiment and make alterations to the composition and colours as the painting progresses.

Many landscape artists work out of doors on small pencil or watercolour sketches of the subject and return to the studio, using the drawings as reference material for larger paintings. This is far more convenient than carrying cumbersome equipment from place to place – especially if the weather is unreliable. It also allows the artist to observe the subject more closely and gather a great deal of information on form, colour changing light, textural details and so on.

Simple sketches are also an invaluable way of 'editing out' superfluous details and helping to capture the essence of the subject; painting in the field, it is all too easy to become overwhelmed by the complexity of the scene. Working from sketches, back at the studio, also allows the artist to use his or her imagination to play about with the subject and get closer to the original experience.

MATERIALS USED

SUPPORT

■ prepared canvas board measuring 20×24in/ 50×60cm

BRUSHES

- Nos. 3, 6, 8, flat bristle brushes
- No. 4 sable

COLOURS

- ivory black
- burnt umber
- cadmium yellow
- chrome green
- cobalt blue
- gold ochre
- lemon yellow
- olive green
- raw umber
- ultramarine blue
- viridian
- vermilion
- titanium white

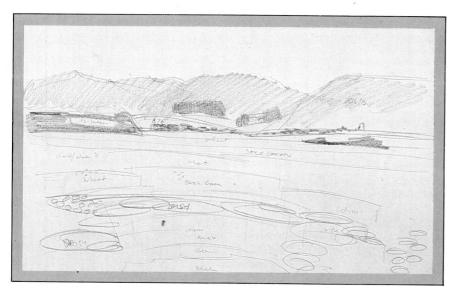

2 The artist starts with a broad underpainting of thinly diluted paint. The basic forms of the

landscape are indicated with a mixture of gold ochre and raw umber, applied with a No. 8 bristle brush.

3 A thin glaze of warm orange is applied in the foreground, and olive green over the distant hills. A thicker layer of lemon yellow is applied across the centre.

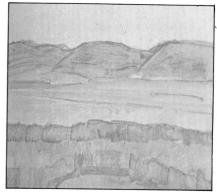

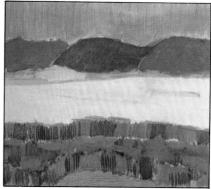

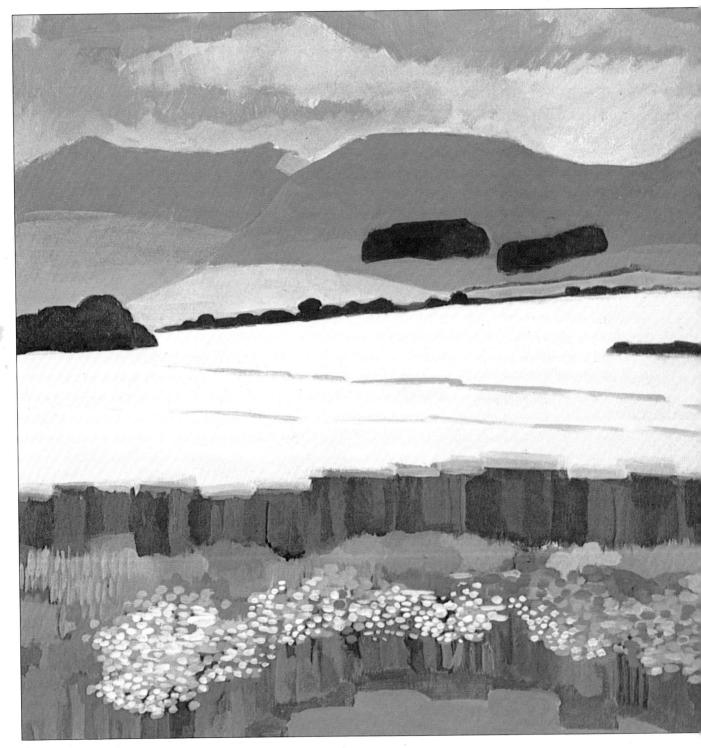

10

10 The finished painting. The artist has exploited both the opacity and the transparency of acrylic to build up a variety of subtle textures and forms. The measured use of horizontal and vertical strokes enhances the mood of calm and tranquility. Note, too, how the warm yellow underpainting is allowed to break through the subsequent layers of colour, helping to harmonize the colour scheme.

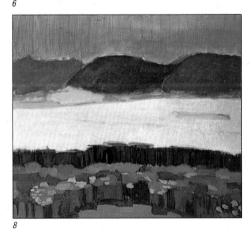

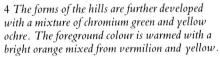

- 5 The artist applies thinly diluted cobalt blue over the sky area, spreading the colour with a rag. The foreground is further developed with a vivid green made of chrome green and lemon yellow.
- 6 The artist develops foreground details with a variety of greens and greys, working with thin glazes of colour and thick dabs of opaque paint.

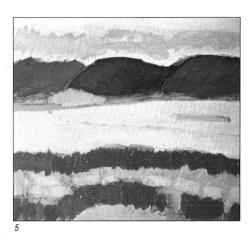

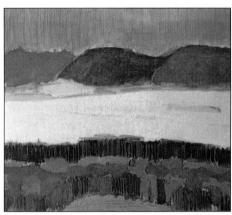

7 Background details are added with a No. 3 bristle brush and a thick mixture of chrome green and black. The foreground is lightened by adding small patches of light green and white.

- 8 The artist lightens the tone of the sky and links it with a pale blue-green in the foreground. A mixture of light orange and white is used to intensify the colour of the distant cornfield.
- 9 The tone of the central field is brightened with a smooth layer of creamy yellow mixed from gold ochre, white and a touch of green.

LIGHTHOUSE

ALTHOUGH ACRYLIC PAINTS are a relatively new arrival in the painting world, their use has spread rapidly, since they are flexible enough to accommodate traditional styles of painting as well as modern styles. For example, their fast drying time and ability to be thinned to the consistency of watercolour make them ideal for the classical approach of building up layers of colour one upon the other: a technique known as glazing.

In the past, almost all paintings were done this way. Many of the Old Masters spent a great deal of time developing the underpainting, which was then finished off with thin glazes of colour through which much of the underpainting remained visible. What we see when we look at a Velasquez or a Rubens are simply the last steps the artists took to complete the picture, hiding much of the underpainting below the surface.

For this painting of a seascape at dusk, the artist chose to use a reddish underpainting which would give the whole picture a warm tone. He has also used the traditional method of working from dark to light, and building up slowly from general forms to more specific details.

MATERIALS USED

SUPPORT

■ prepared canvas board measuring 24×26in/60×65cm

BRUSHES

- No. 3 synthetic fibre brush
- Nos. 2, 3 and 4 bristle brights
- Nos. 4 and 5 sable rounds

COLOURS

- alizarin crimson
- burnt sienna
- burnt umber
- cadmium green
- cadmium red light
- cadmium yellow
- cobalt blue
- phthalo blue
- ultramarinetitanium white

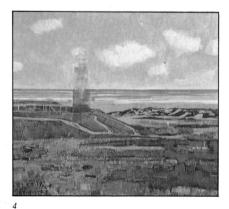

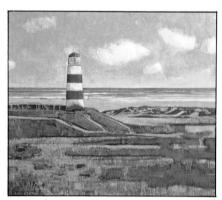

5

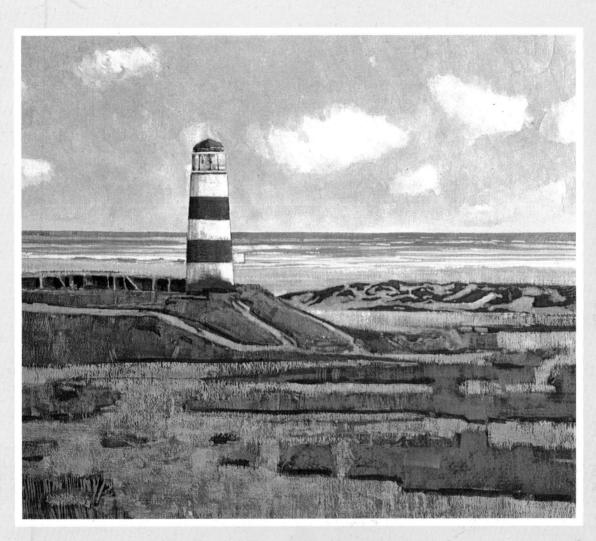

Lighthouse

- 1 The artist mixes burnt sienna with water to a thin consistency and applies it quickly and loosely with a broad brush, blocking in the main areas of the composition.
- 2 The sky tone is a thin wash of alizarin crimson, again brushed in loosely. The lighthouse is painted with a thin wash of burnt sienna, and the ground is covered with a darker, more opaque tone.
- 3 A thin wash of ultramarine is brushed into the sky area. Small patches of grass are indicated with chrome green and cadmium yellow medium. When this is dry, the foreground is lightened with vertical strokes of yellow ochre and white.
- 4 A very thin wash of phthalo blue is put in for the sea, and highlights are redefined with yellow other and white.
- 5 The artist mixes alizarin crimson and burnt sienna and carefully puts in the lighthouse stripes with a small sable brush.
- 6 In the finished painting, you can see how the reddish tone of the underpainting glows up through the succeeding layers of colour, imparting an overall warmth that enhances the peaceful mood of a seascape at dusk.

VIEW ACROSS THE ROOFTOPS

THESE DAYS, many of us dwell in towns and cities, and are often far removed from the traditional subjects of the landscape painter: hills, valleys, rivers, coastlines and so on. The city does, however, offer exciting opportunities for those artists who are prepared to seek out more unusual subjects.

One of the most accessible subjects we have is the view from our own window. A high window, in particular, offers an excellent vantage point and can be just as exhilarating as looking at a view from a mountain top. The geometric shapes of buildings and rooftops, for example, can afford the opportunity to create bold, dynamic compositions in which shapes, colours and patterns are emphasized.

The particular view illustrated in this painting is a fine example of how an artist with a searching eye can find a certain beauty in even the most commonplace subject. Out of a cluttered jumble of buildings and rooftops, he has created a calm and ordered composition in which roughly half the canvas is given to empty sky and the other half to lively geometric patterns.

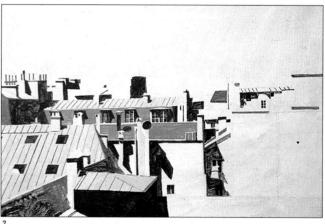

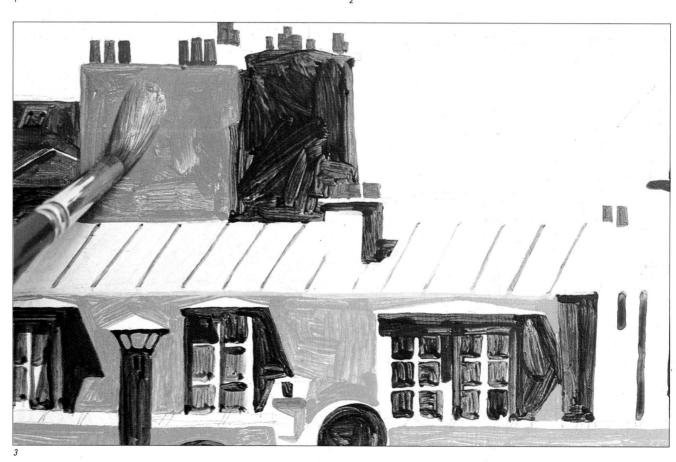

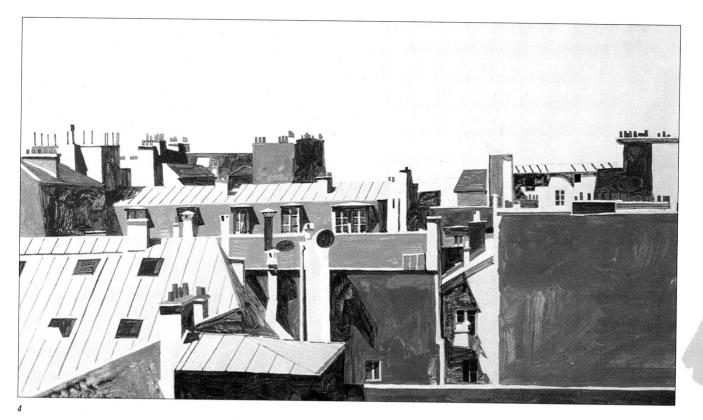

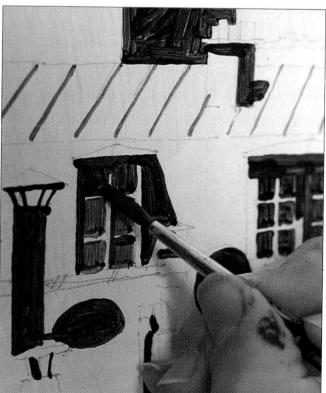

- 1 The subject is complicated, and the artist starts by making a drawing in which he simplifies the tones and colours.
- 2 A fairly detailed outline drawing is made on the support. The artist begins by blocking in the darkest areas using a mixture of black and raw umber, well diluted.
- 3 The middle tones are blocked in next, using Payne's grey and a No. 3 sable brush.
- 4 The artist now begins to add colours over the original dark tones, using mixtures of white, yellow ochre, cadmium red and burnt sienna.
- 5 The painting is now developing into an interesting pattern of abstract shapes and colours.
- 6 This detail reveals the thinness of the paint, and how simply the blocks of colour are applied.

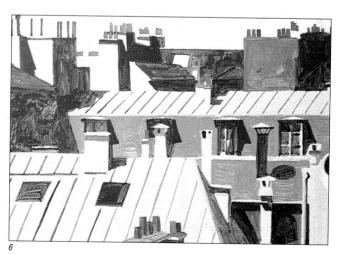

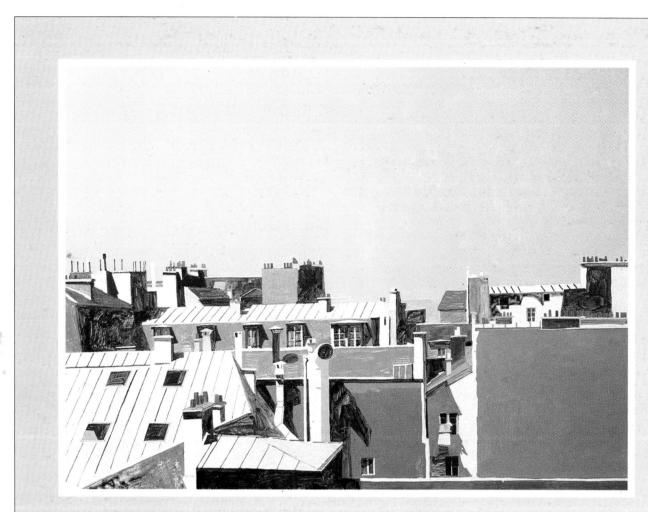

View across the rooftops

8

7 The artist adds details using rich reds and beiges mixed from Payne's grey, yellow ochre and white.

8 In the final painting the sky has been added with a flat wash of cerulean blue mixed with titanium white, toned down with a thin glaze of raw umber. The artist has resisted the temptation to fill the picture with too much detail; the large, empty space of the sky provides an exciting contrast with the clutter of roofs beneath.

MATERIALS USED

SUPPORT

■ hardboard primed with emulsion measuring 22×26in/56×66cm

BRUSHES

- No. 6 sable
- No. 10 synthetic fibre

COLOURS

- Payne's grey
- ivory black
- cadmium yellow
- yellow ochre
- cadmium red
- burnt sienna
- raw umber

■ titanium white

FRUIT TREES

THE CENTRAL THEME of this picture is the brightly coloured fruit trees sparkling in the sunshine, contrasted against the slanting shadows of the street below.

The painting is based on a small sketch, rapidly executed while the artist was on holiday in the Mediterranean. Over the years he has amassed a large collection of sketches like these, which he does not regard as 'finished drawings' but rather as records of interesting scenes or objects, which can be used later, either as foundations for complete paintings done later in the studio, or as fragments to be inserted into other compositions.

The habit of always carrying a sketchbook is an invaluable one, particularly when travelling abroad. You may be just 'passing through' a place, and yet a scene or objects presents itself as an ideal subject for a painting. A sketch can be done in minutes, and provides enough information about the subject to allow you to make a painting at a later date. A photograph may also help, but with a sketch you can make a more personal statement, isolating and emphasizing those elements which particularly appeal to you. A photograph is much less selective, and besides, there is no guarantee that it will turn out as you expected!

Because acrylic is adhesive, the paint can be mixed with other substances such as sand or grit and thus interesting textural effects can be obtained. In this painting the artist has mixed ordinary builder's sand with the paint in order to capture the rough sandy surface of the stone wall.

1 This small sketch was made several months prior to the painting, yet it gives the artist enough to kindle his imagination and memory because it includes written colour notes and details about the play of light and shadow.

2 The artist begins by transferring the image onto a primed canvas in black paint applied with a sable brush.

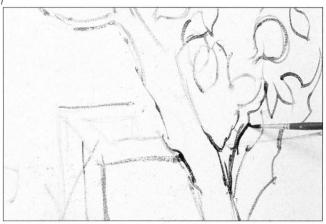

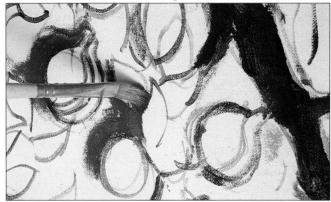

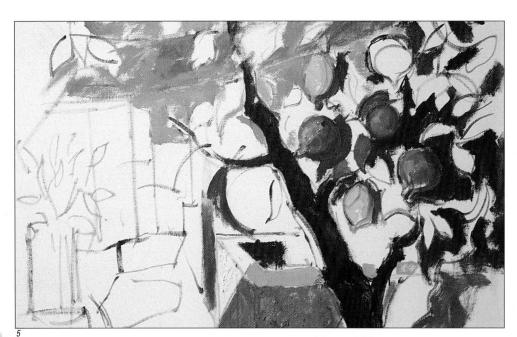

5 Colour is laid on in small, thick dabs to create a lively surface texture. The artist moves across the whole canvas, building up the image bit by bit.

MATERIALS USED

SUPPORT

■ hardboard treated with acrylic primer, measuring 18×14in/46×36cm

BRUSHES

- Nos. 2, 5 and 10 flat bristle
- No. 2 round sable

COLOURS

- cadmium yellow
- cadmium red
- red oxide
- chrome green
- Hooker's green
- bright green
- burnt siennaraw sienna
- raw umber
- cobalt blue
- cerulean blue
- ultramarine
- ivory black
- titanium white

6 Tones of warm brown are worked into the black tree trunks. Because acrylic dries to an opaque finish, light tones can be laid over darker ones without any danger of the darker colour showing through.

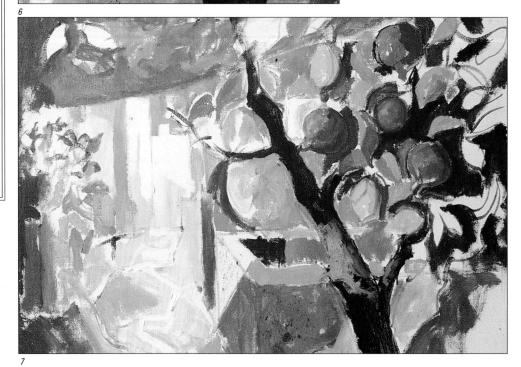

7 The painting is now almost complete. The paint is applied directly, in the alla prima technique, in keeping with the liveliness of the scene. The colours, too, are selected for their suitability to the bright, sunny nature of the subject.

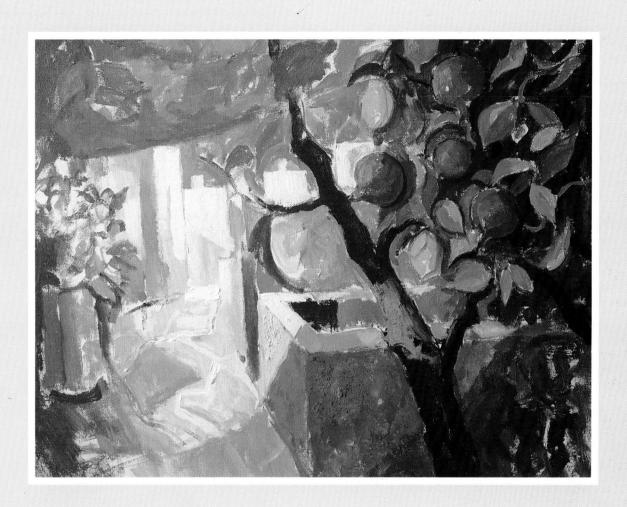

Fruit Trees

8 The artist has created a highly personal interpretation of the scene, which is much more exciting than a mere photographic copy.

Because the scene is viewed from the shade of a pavement café, there is a frame of shadow around the picture which helps to focus the eye upon the brilliantly sunlit street. Although the colours are bright, they are nevertheless harmonious; yellows, greens and earth colours have been skilfully woven throughout.

THE THAMES AT RICHMOND

THIS LEAFY RIVER SCENE is one which is very familiar to the artist who painted it, since it lies directly beneath the window of his studio. It provides an endless source of inspiration to the artist, as the colours change with the passing of the seasons.

The success of this picture lies in its simplicity, which captures the tranquil calm of a summer's day. Acrylic paint can be diluted with water or medium to the consistency of watercolour, allowing delicate, translucent effects to be obtained. For this painting, the artist chose to work in the

- 1 A photograph of the view from the artist's window. Compare this to the finished painting, and notice how the artist has simplified much of the detail to arrive at the essence of the scene.
- 2 Without any preliminary underdrawing, the artist begins by blocking in the main areas of the composition with pale tints of Payne's grey and raw umber.
- 3 While the first tones are still damp, washes of Hooker's green mixed with a little raw umber in the shaded areas, are worked into the trees and the foreground.
- 4 The quiet ripples on the water's surface are indicated with pale lines of Payne's grey and raw umber.
- 5 The artist uses sable brushes throughout the painting process, to achieve the softness of form and delicacy of detail necessary.
- 6 The artist strengthens the tones in the painting by applying glazes of colour, one on top of the other. The glazes are very thin and transparent, allowing the underlayer to glow up through the overlayer and create the luminous effect of a watercolour painting.

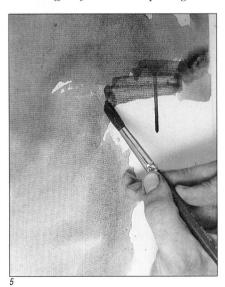

manner of a watercolour. Without any preparatory drawing or underpainting, he applied his colours directly onto a sheet of stretched paper. Working from light to dark, in the traditional watercolour manner, the artist applied the colours in thin, transparent glazes which allow light to reflect off the white of the paper and up through the colours, giving them a luminous quality.

Because the washes are so transparent, mistakes cannot be covered up, so it is important to get things right first time – especially since acrylic dries so quickly. The best way to work is boldly and decisively – as the artist did in this painting.

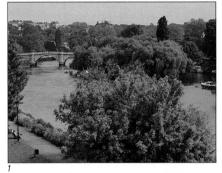

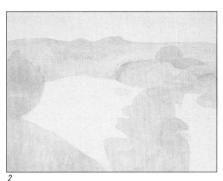

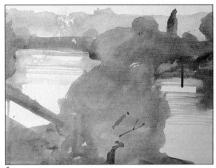

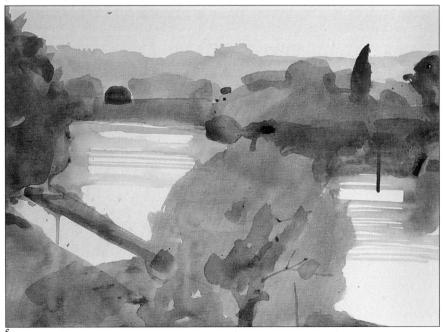

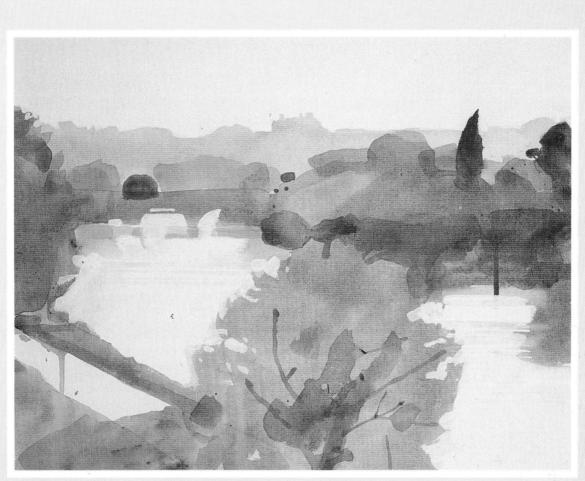

The Thames at Richmond

7 Opaque white is used to redefine complicated edges such as the leaves on the trees. The paint is not used thickly but is still watery in texture.

8 The completed painting has all the freshness and sparkle of a watercolour. The artist has resisted the temptation to overwork the washes or to build up the paint in opaque layers. In addition, he has cut out much of the detail in the scene and presented us with his own personal interpretation of a much-loved subject.

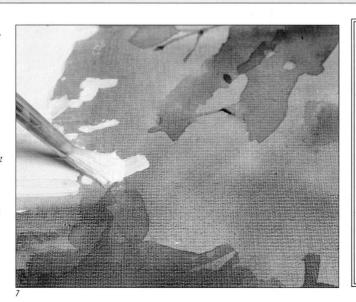

MATERIALS USED

SUPPORT

■ stretched Bockingford watercolour paper measuring 16×12in/ 40×30cm

BRUSHES

■ Nos. 4, 6 and 10 sable

COLOURS

- Payne's grey
- ivory black
- Hooker's green
- yellow ochre
- raw umber
- burnt sienna

■ titanium white

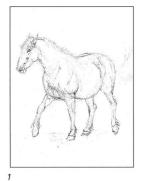

1 One of the drawings that became the basis of the horse in the painting - though in reverse.

- 2 The artist makes a detailed drawing of the subject with a 3H pencil. He then applies a very dilute wash of burnt sienna over all the parts of the horse which will be brown.
- 3 The background and foreground are washed in with very pale tints of blue and green.

SUFFOLK PUNCH

ACRYLIC is a popular painting medium with animal artists. Its rapid drying time means that artists do not have to struggle home with a wet canvas after a day's work in the field. In addition, its versatility means that it can be used to render a wide range of textures, from the softness of fur to the clean, sharp lines of a bird's feathers.

The artist has been painting animals all his life and so has an extensive knowledge of their anatomy, appearance and characteristics. This painting was developed from two separate drawings of the horse and the dog, made at different times and then combined into a picture that derives as much from imagination as from fact. It is a good idea to keep a sketchbook with you at all times, so you can make drawings of things that interest you and which can later be incorporated into your paintings.

As is often the practice with acrylics, the artist has here used a combination of transparent and opaque techniques. This combination of thin washes and opaque colour creates a range of textures which reflect the quality of the surfaces they describe. The finished result resembles transparent watercolour and body colour, because very little thick paint has been used and only sable brushes have been employed.

MATERIALS USED

SUPPORT

cartridge paper measuring 11×15in/ 28×38cm

BRUSHES

■ No. 6 sable

COLOURS

- raw umber
- burnt sienna
- bright green
- cadmium yellow
- cadmium red
- cobalt blue
- ivory black
- titanium white

4 To create an impression of mistiness in the foliage, the artist wets the paper in that area and allows the colours - raw umber and bright green – to blend so that they diffuse with soft edges.

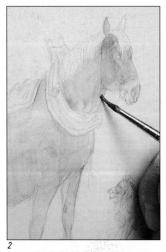

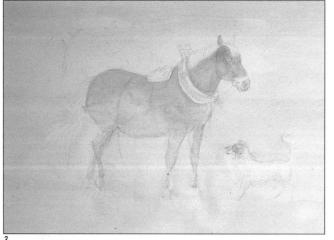

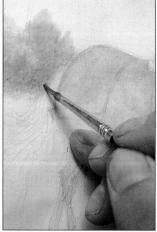

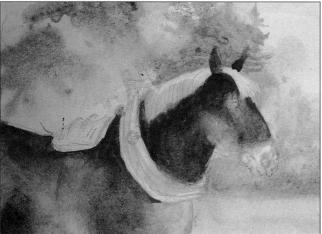

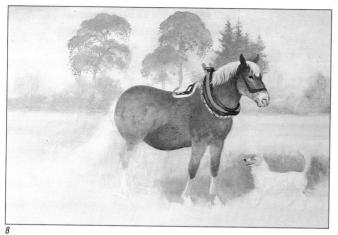

Suffolk Punch

10

5 The trees are treated in a similar way, but more opaque paint is added for the fir trees. When the background washes are dry the artist continues to work on the body of the horse, using a series of transparent washes of burnt sienna.

6 The artist works on one of the trees, stippling opaque colour over

a pale underwash to build up texture and form in the foliage.

7 With the broader areas now established, the artist starts on the finer details. Here he is using a fine brush and thick white paint for the horse's mane.

8 For the grass the artist uses bright green and a No.6 sable

brush, adding raw umber and white in the shadow areas.

9 This detail shows how the artist works around the shape of the dog.

10 The final painting. Only in the latter stages does the artist add the finer details. The dog's coat, and the characteristic plumes of hair on the horse's legs, are added using thin white paint, and then the harness and chains are added with black, red, yellow and white. The lesson we learn from this painting is that it is better to begin broadly and only finalize our work, and adding in the detail, in the latter stages. Working from large to small, and from light to dark, is the ideal way to control a painting.

1 The painting evolved from these sketches made at the zoo.

2 The artist begins by making an accurate drawing of the subject on the canvas with a B pencil.

CHIMPANZEE

APES RESEMBLE HUMANS in many ways, except that they have a good deal more charm. Chimpanzees are particularly endearing, with their bright, curious eyes and their impish behaviour – qualities which are captured in this delightful 'portrait'.

This painting was developed from sketches made at the zoo, supplemented by photographic reference in natural history books. The artist's approach, however, is not merely to make a slavish copy of the subject; rather, he aims to capture something of the character of the animal, to reach further than just surface appearance. A great deal of imagination is brought into play, and the artist allows the medium itself to play its part in translating the essential character of the subject.

Another important aspect of painting is choosing the format and viewpoint that best express what you want to say. In this painting, for example, the artist has chosen a landscape format, rather than a portrait shape which might seem more obvious, given the shape of the subject. The chimpanzee is placed low down in the picture, and this somehow communicates a clownish, comical air which is entirely in keeping with the subject of the painting.

3 The main shapes of the body are blocked in with broad strokes of raw umber, burnt sienna, ivory black and Payne's grey.

4 The sky is blocked in with a mixture of cerulean blue and titanium white, applied with a No. 6 flat bristle brush.

5 The artist now begins work on the chimpanzee's face – the most important part of the composition. He starts by laying in the darkest tones using a mixture of yellow ochre, raw umber, ivory black and cadmium red. The colour is thinly diluted with turpentine and applied with a No. 7 Dalon brush, with a No. 2 sable brush for the finer lines.

6 The artist lightens the mixture used for the face by adding more white and yellow ochre and starts to lay in the middle tones.

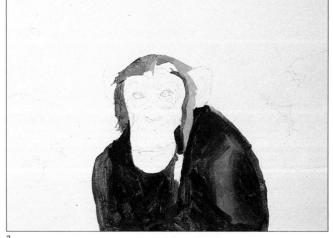

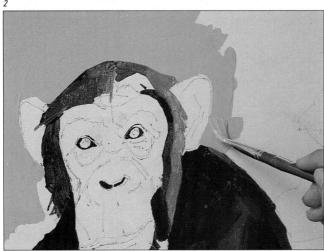

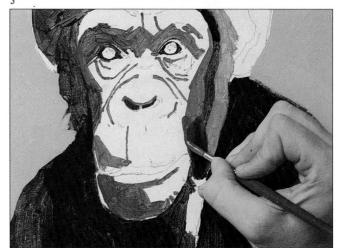

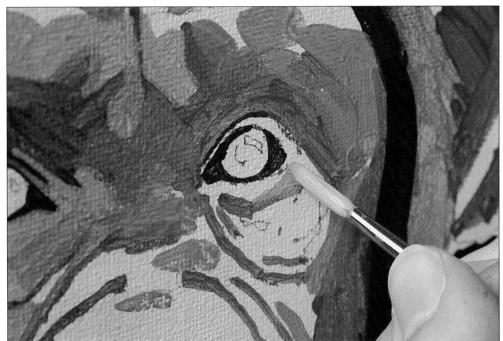

MATERIALS USED

SUPPORT

■ prepared canvas panel measuring 20×24in/ 50×60cm

BRUSHES

- No. 2 sable
- No. 7 synthetic
- No. 6 bristle

COLOURS

- raw umber
- burnt sienna
- Payne's grey
- ivory black
- cerulean blue
- yellow ochre
- cadmium yellow
- sap green
- cadmium red
- titanium white

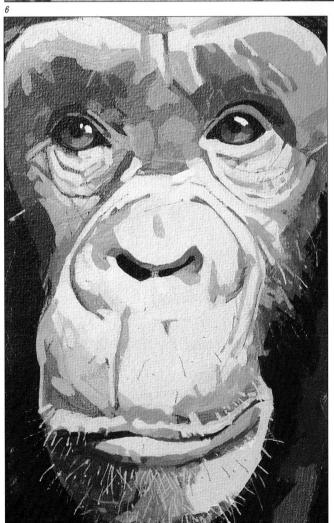

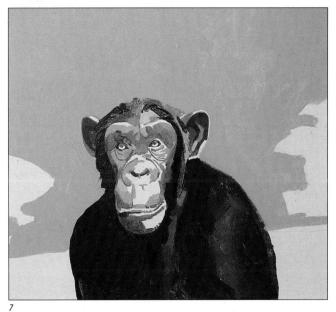

7 Because all the large areas have been dealt with the painting builds up very quickly. This is useful, because it gives the artist something against which to judge subsequent tones and colours.

8 The lightest tones in the face are now added, by adding cadmium yellow and more white to the original mixture. When the paint is thoroughly dry the artist scratches into it with a craft knife, making fine marks which indicate the whiskers on the chimp's chin.

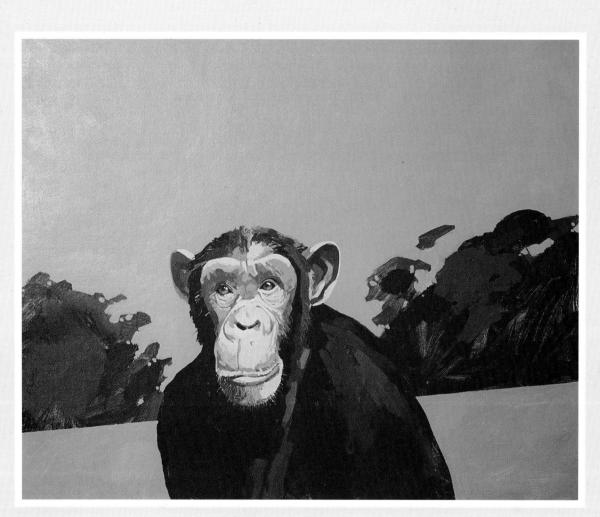

Chimpanzee

9 Using mixtures of sap green and ivory black, the artist indicates the trees in the background. When the first paint layer is dry the artist puts in the lighter foliage, created by adding white and yellow ochre to the original green mixture.

10 Using masking tape to protect the surrounding areas, the artist blocks in the grey background with Payne's grey, yellow ochre and titanium white. The finished painting has a charm and directness which is perfectly matched to the character of the subject. The way the subject is placed within the edges of the support creates a series of simple shapes which are an important feature of the composition.

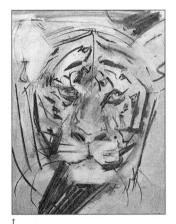

1 One of the many charcoal sketches which the artist made, using photographs as reference. The end of a thin stick of willow charcoal is used to achieve crisp lines, while tone and modelling are achieved by smudging and smearing the charcoal.

2 Before starting to paint, the artist makes a simple charcoal drawing on the canvas to fix the position of the subject and outline the main features.

[IGER

PAINTING AN ANIMAL involves much the same sort of challenge as painting a human portrait: we must aim not only to capture a likeness of our subject but also to convey something of their character and personality. In this painting of a tiger the artist has used his skill to portray the animal's strength, intelligence and awesome beauty.

The power and directness of this painting belies the fact that the artist worked entirely from photographic reference. He did not merely copy the photographs, however; instead, he used them as a starting point for the study. His own imagination, and his feeling for the subject, provided the spark of inspiration that turns what could have been an ordinary painting into something more meaningful.

Another point to bear in mind is that the artist did not begin painting straight away. Instead, he made many pencil studies of his subject, in which he investigated the facial markings, the structure of the head, the proportions of the body, and so on. This process can be compared to a dancer learning steps, or a musician practising scales: all the sweat and labour of the preliminary work is what, in the end, will lead to success.

4 The artist starts to lay in broad strokes of colour immediately, without any underpainting. The paint, raw sienna and cadmium yellow deep, is applied with a 1-inch decorator's brush to encourage a free, spontaneous approach.

5 The artist now blocks in the background with vigorous brushstrokes, using the same decorator's brush and sap green diluted with water. Notice how the brushstrokes remain visible, adding drama and movement to the image of the tiger.

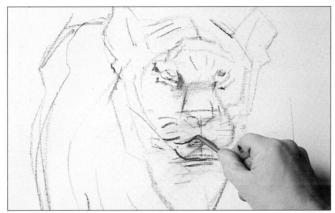

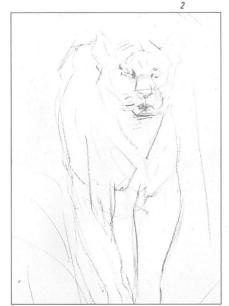

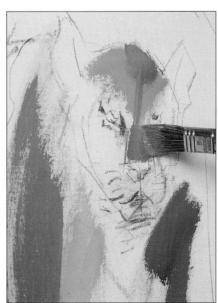

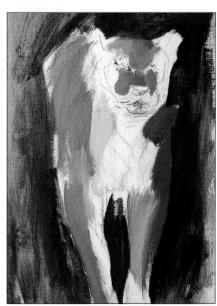

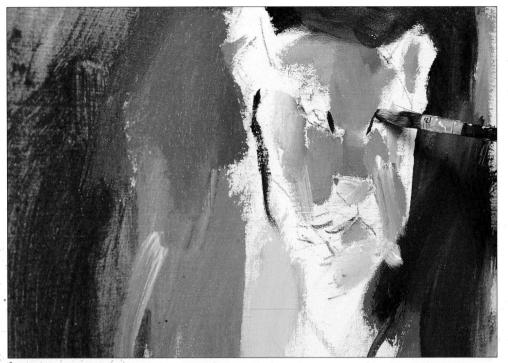

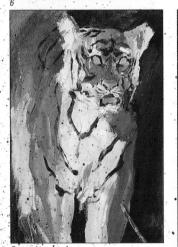

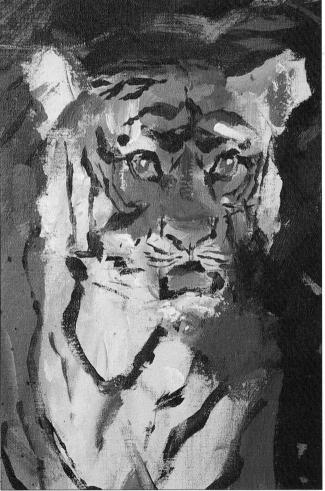

6 With the main areas established, the artist begins to work on the details of the tiger's features. Here a No. 12 ox-hair brush is being used to paint the striped markings on the face.

7 The artist continues to apply colour all over the painting, often stepping back from the picture to assess its progress. The broad strokes of yellow, white and black are now beginning to come into focus.

8 In this detail we see just how exciting the paint surface is. The broad, loose marks create a dynamic force which animates the picture and makes us feel as though the tiger is about to pounce.

9 The finished painting demonstrates how a fast, vigorous, alla prima technique creates an exciting impression of a subject such as a wild animal. Acrylic paint dries quickly, allowing the artist to work fast and keep the paint surface fresh and lively. The image of the tiger emerges convincingly from the vigorous brushwork, the separate areas of bright colour merging in the viewer's eyes. Note also how the artist deliberately confines the subject within the narrow limits of the picture's boundaries, giving the impression that the tiger is about to burst from the painting.

MATERIALS USED

SUPPORT

■ ready-primed flax canvas measuring 30×20in/ 76×50cm

BRUSHES

- 1-inch decorator's brush
- No. 12 round ox-hair
- No. 8 sable round
- No. 4 bristle round

COLOURS

- raw sienna
- cadmium red
- cadmium yellow
- cadmium yellow deep
- sap green
- ivory black
- titanium white

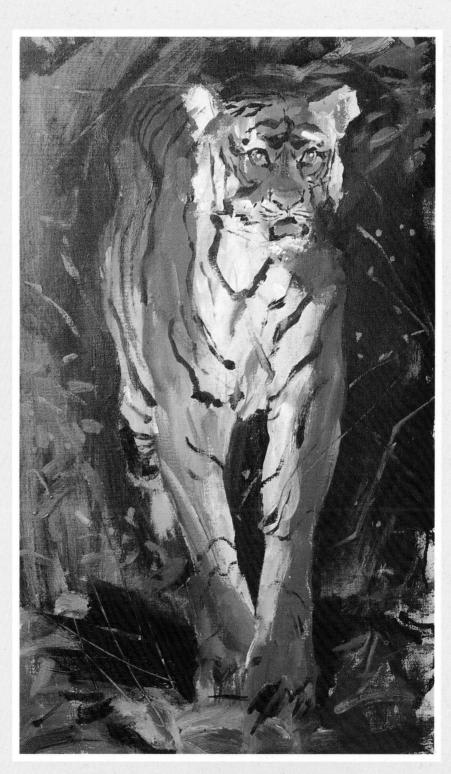

Tiger

1 The subject of this painting was the artist's own falcon, sitting on an Arab-style perch.

LANNER FALCON

THE SUBJECT OF THIS PAINTING is a Lanner falcon, a native of the Mediterranean and North Africa. This particular bird, posing regally on its Arab-style perch, belongs to the artist. Falcons are his special love, and he knows the subject so well that he is able to paint the details and wing patterns of these birds virtually with his eyes closed!

What we can learn from the artist is that the better you know your subject, the more likely that you will be able to do justice to it. If you really want to succeed, it isn't enough to paint a subject just once and then forget it. The more you practise the more skillful you become; there is, unfortunately, no other way to fulfill your hopes and ambitions when trying to master acrylic. Fortunately, the practice of painting with acrylics always offers some kind of pleasure. And if you see every attempt that you make not as a final attempt, but just another form of practice, the fear of failure will be lessened. In turn, your more relaxed attitude will show in your paintings, which will show a bolder, more confident use of form and colour.

MATERIALS USED

gesso-primed hardboard measuring 20×16in/ 50×40cm

BRUSHES

■ Nos. 4 and 7 synthetic and a 1-in bristle brush

COLOURS

- burnt sienna
- cobalt blue
- Turner's yellow
- yellow ochre
- brilliant orange
- acadmium red medium
- ultramarine
- Payne's grey
- titanium white

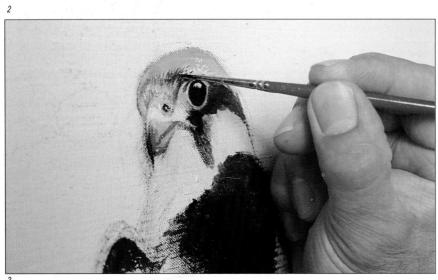

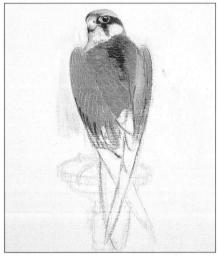

- 2 The artist begins by making a drawing on paper. He transfers this to the canvas by covering the back of the drawing with charcoal powder and tracing over the lines of the drawing with a 4B pencil.
- 3 The artist starts the painting with the head because the eye and the beak are important in capturing the personality of the subject. If he gets these right, the painting will succeed.
- 4 Now the artist blocks in the body of the bird with a mixture of Payne's grey and raw umber. He then draws the scalelike shapes of the feathers with a small brush and light grey paint.

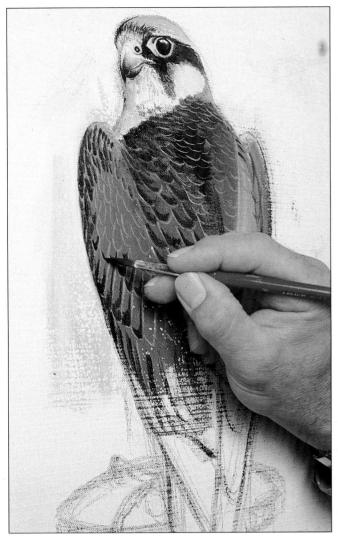

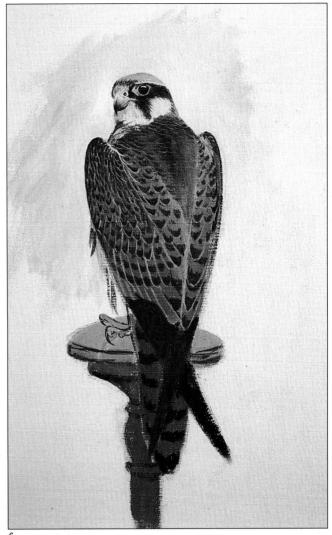

- 5 He then develops the shading on the feathers with tiny hatched brushstrokes of raw umber and black, applied with a No. 2 brush.
- 6 The artist develops the details on the neck of the bird with white paint, smudging it with his finger to give a soft texture. He then continues working over the plummage, and lightly blocks in the background with loose strokes of white and yellow ochre.
- 7 The artist highlights the tips of the wings with light grey, then gently smudges the paint with his finger to create a soft, feathery edge.
- 8 The background is darkened with a mixture of burnt sienna and yellow ochre, applied loosely with a No. 5 bristle brush. The artist is not happy with this, however, as he feels it detracts from the main subject.

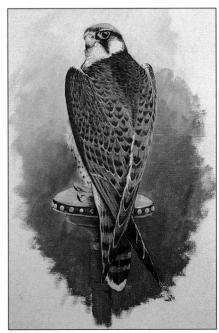

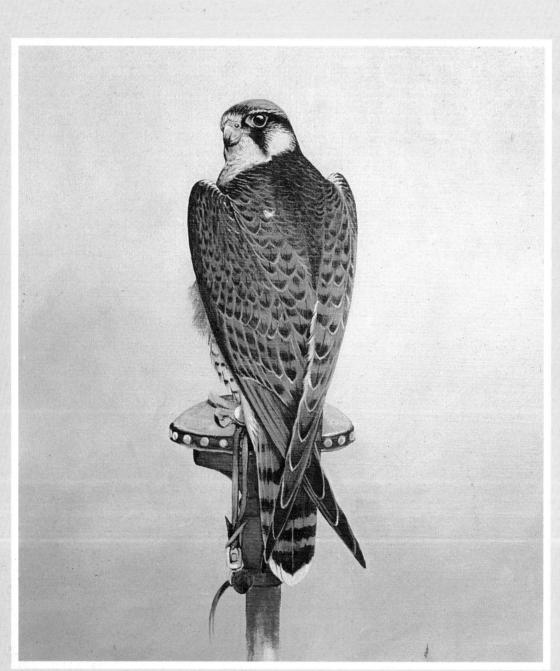

Lanner Falcon

9 In the finished painting, we can see how the artist has overlaid the dark background with a pale, neutral one which gives much greater force and power to the image of the falcon. The removal of the dark background was easily accomplished thanks to the efficient covering power of acrylic paint; even the darkest colour

will not show through a light one laid over it. Also, acrylic paint dries to a hard, impermeable finish which means that a fresh layer of paint cannot 'pick up' the colour underneath and cause muddiness, as sometimes happens with other, less versatile painting media.

1 The artist begins by making an outline drawing of himself on the canvas, using a B pencil. He then blocks in the main light and shadow areas on the face with broad strokes of burnt sienna, diluted with water for the light areas.

3 This close-up reveals how the artist is building up the broad masses and planes of the face with thin washes of colour which indicate the light, medium and dark tones.

SELF-PORTRAIT

IF YOU ARE LOOKING FOR a convenient model for a portrait painting – someone who is inexpensive, reliable and available at times that suit you – then there is no better subject than yourself. Painting a self-portrait also has the added advantage that you don't have to worry about flattering your sitter!

Acrylic paints are an especially suitable medium for selfportraits. Their consistency can be varied to suit a whole range of styles, from loose and impressionistic to tight and realistic, depending on the mood you wish to convey.

Strangely, it is usually difficult to 'see' ourselves properly. You may think you know your own face extremely well, but when it comes to painting a portrait it is essential to study your features as if for the very first time. If necessary, make a series of sketches before you begin the actual painting.

When posing for a photograph, many of us tend to look awkward and self-conscious. The same thing can happen with a self-portrait, so try to relax in front of the mirror and select a comfortable pose. It is a good idea to mark the position of the easel, the mirror and your feet so that when you come back to the painting you will be able to take up the position again.

For this self-portrait the artist chose an unusual but effective composition in which his own image is cropped off at the corner. His shadow cast on the wall behind helps to stabilize the composition and adds three-dimensional depth to the image.

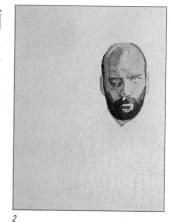

2 Now the dark tones of the hair, beard and moustache are put in with burnt sienna darkened with cobalt blue.

4 The artist continues to model the face using various tones of earth colours such as burnt sienna, burnt umber, Turner's yellow, brilliant orange and raw sienna. The eyes are painted with Payne's grey and black, and the mouth with red ochre.

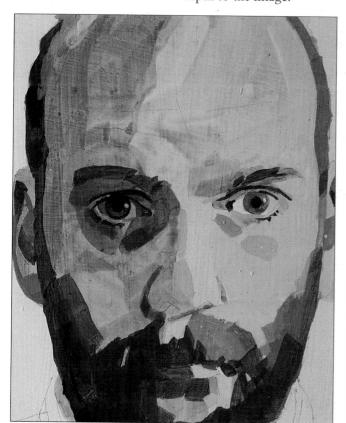

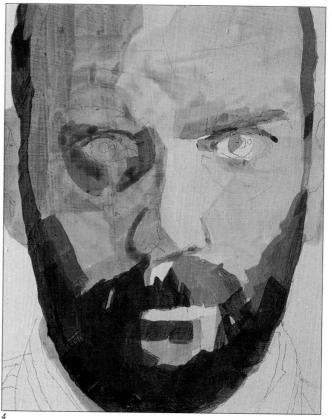

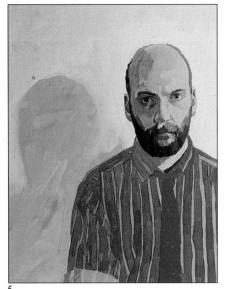

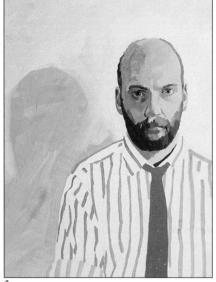

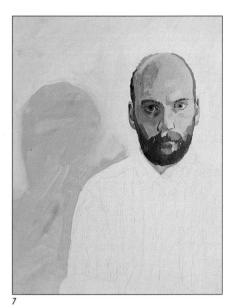

- 5 Now the cast shadow on the wall is brushed in with a 1-in bristle brush and a weak solution of Payne's grey, white and yellow ochre.
- 6 The details of the shirt and tie are painted with a No. 3 sable brush and cadmium red medium and brilliant orange.
- 7 Washes of ultramarine blue complete the colouring of the shirt. These bright, vibrant colours are deliberately chosen to bring a touch of vitality to the otherwise sombre composition.
- 8 The artist now completes the modelling of the head and the facial features. The highlights in the skin tones are added with thin washes of Turner's yellow and white, and white highlights indicate the reflections on the mouth and eyes.

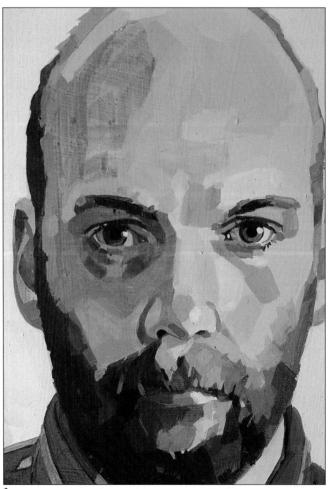

MATERIALS USED

SUPPORT

■ gesso-primed hardboard measuring 20×16in/ 50×40cm

BRUSHES

■ Nos. 4 and 7 synthetic and a lin bristle brush

COLOURS

- burnt sienna
- cobalt blue
- Turner's yellow
- yellow ochre
- brilliant orange
- cadmium red medium
- ultramarine
- Payne's grey
- titanium white

9 The finished portrait. Notice how the unique placement of the figure and the use of clean, white space around it force the viewer's eye into the face of the subject. The strong colours of the shirt and tie contrast boldly with the white of the paper and create a dynamic visual tension.

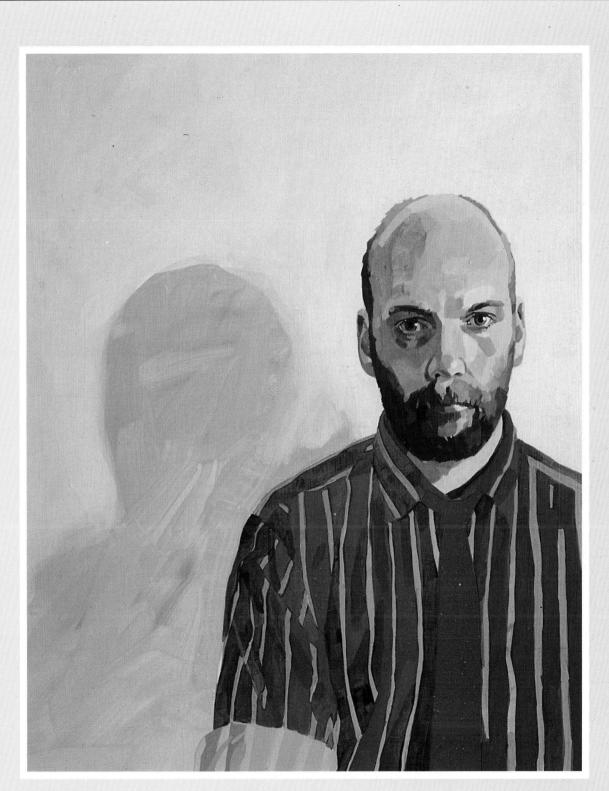

Self Portrait

1 Before starting to paint, the artist made sure that the model was sitting comfortably and in a relaxed position.

2 Working with black, white, vermilion and burnt sienna, the artist blocks in an overall impression of the figure. The colours are loosely applied with thin paint to allow for correction as the painting develops.

WOMAN IN A SPOTTED DRESS

PAINTING A PORTRAIT makes more demands on an artist than any other subject. In creating a likeness, every feature of the head and face must be carefully analyzed in terms of colour, shape and tone. Because the character of the image is dependent upon this detailed analysis, small adjustments at any stage of the painting can make all the difference between success and failure.

The sympathetic nature of acrylic paints can help to overcome some of the problems of portrait painting. Unlike watercolours, which are difficult to control, and oils, which are slow-drying, acrylics allow you to work at a comfortable pace, building up the colours layer upon layer. In addition, the opacity of acrylics allows you to make adjustments or cover up mistakes without any danger of the colours turning muddy.

For this portrait, the artist worked 'from the general to the particular'. That is, he established the basic forms quickly with thin layers of paint, gradually working up to the finer details so essential to the individuality of the human face.

This is a standard three-quarter portrait, in which the head is facing at an angle halfway between a profile and a full frontal view. This pose is favoured by many artists, as it has a pleasing naturalness and also creates an interesting shape on the canvas.

MATERIALS USED

SUPPORT

■ stretched and primed cotton duck canvas measuring 20×18in/50×45cm

BRUSHES

- No. 6 flat bristle
- No. 4 round sable

COLOURS

- burnt sienna
- burnt umber
- cadmium yellow
- cobalt blue
- vermilion
- vellow ochre
- ivory black
- titanium white

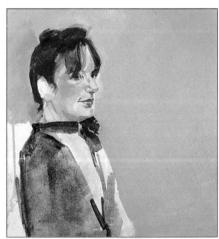

3 The light flesh tones of the face are applied. Cobalt blue is added to the basic flesh tone mixture for the cool shadow areas. When these are dry, rich reds and browns are used to define the mouth. Deep shadows on the underside of the chin and nose are painted as precise, shapes of cool, grey purple.

4 The background colour is applied with a mixture of cobalt blue, yellow ochre, black and white. A thin glaze of black is then applied over the model's dress.

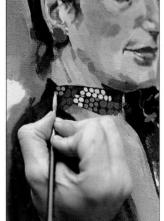

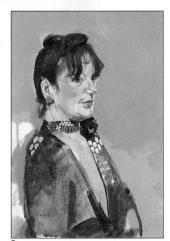

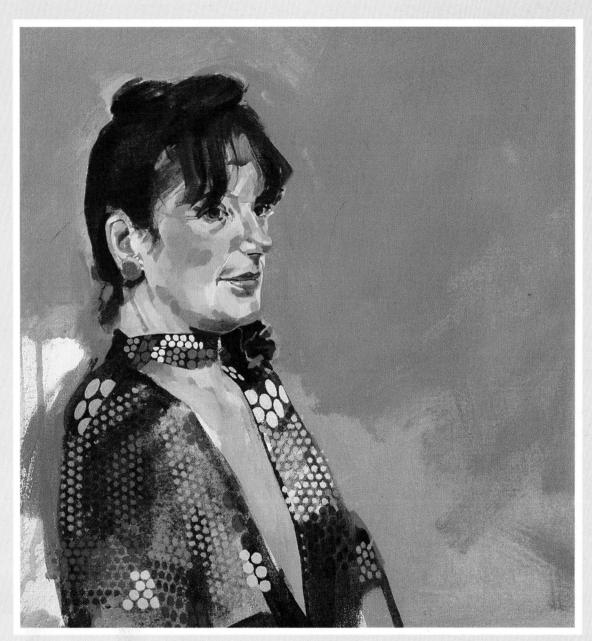

Woman in a spotted dress

- 5 The artist adopts an unusual technique to paint the small coloured spots on the model's dress. Using a piece of perforated scrap metal as a stencil, he stipples the opaque paint into the holes with a bristle brush.
- 6 The stencilled dots are now strengthened with a small sable brush, using white, cadmium yellow and vermilion.
- 7 The artist continues to build up the pattern on the dress. Larger spots are painted freehand.
- 8 The finished painting. By starting with broad strokes and thin paint, the artist was able to establish the pose and the correct proportions of the model in the early stages, without building up a thick, dense layer of paint. Working from this firm
- foundation, he was able to work quickly and confidently when applying the finer details. The completed portrait retains some of the lively, spontaneous strokes made in the early stages of the painting.

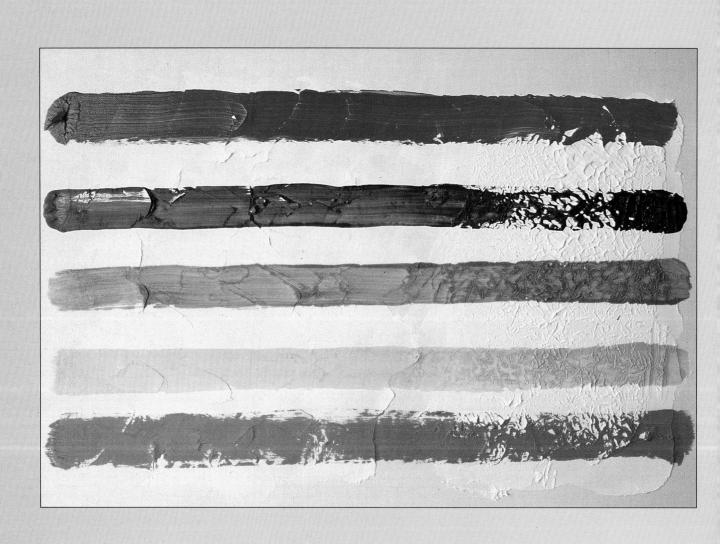

CHAPTER FIVE

DESIGNING WITH ACRYLICS

HANDBOOK of this kind can only touch briefly on design. Such a subject would need a book of its own to do it justice. So I have confined myself to highlighting some of the more obvious things that acrylic is capable of doing.

SOME USES OF ACRYLIC

- Collage
- Simple surface modelling and textural effects
- Staining
- Spraying
- Taping
- Wall decoration and murals
- Drawing and illustration

I try to define design and design methods as exactly as possible.

However, the result will inevitably take on a personal note. As someone who has worked as a painter and designer for many years, I have naturally come to a number of conclusions, some of which are very personal. One conclusion is that all the disciplines – painting, drawing, design and sculpture – have a great deal in common, and relate closely to each other.

I prefer to think of drawing not as a separate activity, but as the base connecting painting and design, for drawing serves them both equally. Therefore if you draw, you are directly concerned with painting and designing, even though the ends to which they are put may differ appreciably.

Without going too deeply into the philosophy of the visual arts, I have taken the view that design has, basically, a decorative function, which confines itself to environment, objects and communication media, and does this principally by the use of colour, shape and form, pattern and texture, and imagery.

Painting, however, though using the same elements of colour and form, is more concerned with expressing an individual point of view. Moreover it may incorporate research of an aesthetic or philosophical nature quite outside the province of design, though design itself may be indirectly related to these researches in no small way. Drawing spans both activities and can be research and communication, decorative and creative, all at the same time.

That painting has influenced design over the centuries is obvious. A great many innovations in posters, furniture, textiles and interiors can be more or less traced to the experiments of painters during this century. Many of these painters were also sculptors and became, in turn, designers themselves, of no mean achievement. Picasso and Braque spring readily to mind as two important artists who left their imprint on design as much as on painting. In many instances the public will reject an artist's researches out of hand, but accept them eagerly when transformed into design. Those who intend to design should bear this in mind and recognize that research is important to all areas of art, and that drawing is perhaps the best form of it.

It is also interesting to note that in French and Italian the word for drawing is the same for design.

Acrylic is also an ideal medium for research and experiment because, like drawing, it is immediate, and research depends on spontaneity and the quick grasp of ideas. Acrylic can offer extended opportunities for going over the same ground until something exciting emerges. In addition it is able to do things that other mediums cannot attempt.

COLLAGE

THE WORD COLLAGE COMES from the French coller to stick – an apt description for a picture or design that is made up from pieces of paper, cloth or other material and stuck to a firm support.

COLLAGE

(1) ABOVE Acrylic medium can be used for collaging. Cut the canvas shape and paint one side with medium.

(2) ABOVE Press the shape onto stretched canvas. Rub it down with a clean, dry brush.

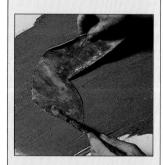

(3) ABOVE Collage can also be done using the adhesive qualities of acrylic paint.

This method of creating images was extensively used by the Cubists, the two main innovators being Picasso and Braque, both painters. In his later years Matisse used pieces of coloured paper as a substitute for painting.

Collage can literally transform discarded bits of cloth and wood and other materials into interesting schemes of

colour, tone, form and texture.

Another sort of collage can be made from waste pieces of wood sawn off frame mouldings. When stuck together in varying combinations, interesting ideas for three-dimensional designs emerged, not apparent in the original material. When the discarded bits were reassembled, completely new forms were created.

You can see even from a few examples the potential of collage, and in particular its pronounced three-dimensional qualities. None has paint added to them in these instances,

though it can be tried with equal success.

In what way exactly does collage involve acrylic, if no paint is used? Quite simply the strong adhesive qualities that the base medium possesses. With it you can stick almost anything to a support.

MODELLING AND SURFACE TEXTURES

ADHESION IS ONLY ONE of the many attributes of acrylic modelling or texture paste. Another is its modelling ability and the way it may be used to make exciting surface textures, with or without the addition of paint. With the simplest of modelling techniques, surfaces can be transformed simply by using this paste.

Sawdust can be added to the acrylic paste to give it more bulk and texture, also a little white primer to give it more body. It can then be thoroughly mixed and spread on to a piece of card (cardboard). Pattern effects can be made by impressing various shapes or edges into the drying surface. Alternatively the paste could be mixed with a little sand, white primer and umber to darken it. Lines can be scratched into it very freely with the back of a brush to create a relief effect. It may then be further stained with colour, and the surplus wiped off.

As another variation, some cellulose filler can be added and some blue to give it a little colour. Lines could be incised on the surface with a comb. When dry this surface could be stained with umber and wiped off before nearly dry. The mixing of the paste with sawdust, sand and cellulose filler, as well as white primer and a little tube colour, gives the paste that is formed an entirely different texture each time. The addition of the white primer to the other aggregates changes the qualities of the paste, for without it the paste dries somewhat transparent.

These few variations give unlimited scope for experiment and if pursued further, would aid an interior designer or stage designer in discovering interesting surfaces by trying out the paste on models or on pieces of card (cardboard), and then lighting them from various angles.

Another method for creating surface textures of a completely different kind is to embed small regular or irregular fragments of objects into a smooth paste. Make up a smooth texture paste of cellulose filler with a touch of

TEXTURES WITH GEL

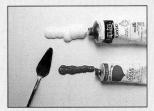

ABOVE Equal proportions of gel and paint are mixed. The thickened colour should be used immediately, as it dries quickly.

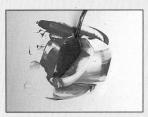

ABOVE A painting knife is used to mix the gel and paint.

ABOVE The result is a paint with a stiff, buttery consistency which retains the shape of the knife marks.

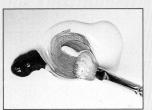

ABOVE Alternatively, a brush may be used to mix the gel and paint in equal quantities.

ABOVE Used with a stiff brush, gel lends itself to rugged brushwork which retains the impression of the bristles.

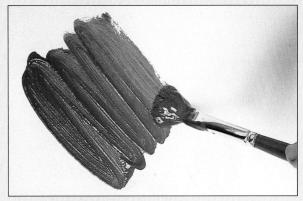

ABOVE The mixture is then applied to the support with direct, spontaneous strokes.

TEXTURE WITH FOIL

(1) Modelling paste is spread evenly over the support.

(2) A piece of crumpled foil is pressed into the paste while it is still wet.

(3) The modelling paste takes on the texture of the foil.

When the paste is dry, it is ready to be overpainted.

The rougher texture creates broken colour where the paint is applied. The finer texture on the right produces mottled patches of colour.

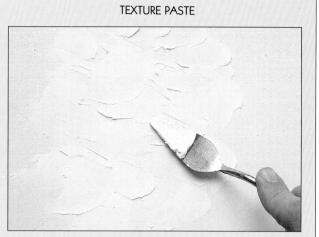

ABOVE Texture paint is applied directly to the support with a knife.

ABOVE The textured surface is painted over to create a delicate glaze.

white primer, and experiment with all kinds of materials – buttons, hairpins, tacks, or staples for regular shaped objects, and peas, lentils, seeds or macaroni for irregular ones.

Three other ways of using acrylic which are ideal for designing purposes are staining, spraying and taping.

STAINING

BECAUSE ACRYLIC IS QUICK drying and waterresistant, and can be used thick or thin with equal ease it can be painted on unprimed cloth, and not only is it perfectly safe, but if it is thin enough, it soaks into the fibres of the material without any loss of brilliance, with remarkable affinities to dyeing and screen printing.

STAINING

ABOVE To stain a support, mix the tube colour with a medium to produce a thin, fluid consistency.

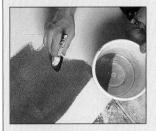

ABOVE Work the colour into the weave of the support using a decorator's brush or a sponge.

This opens up a wealth of possibilities for painting and fabric designing.

Thin colours can be sprayed, dribbled or splashed on to various kinds of cloths to produce a diversity of effects quickly without the bother of any kind of printing process to intervene.

When you try the staining technique, add some water tension breaker (wetting agent) to the water diluting the paint, as this will increase the surface wetting and penetration properties of the colours. The addition of a few drops of matt medium will ensure that the thinned colour will flow well, dry matt and retain the binding properties of the medium.

SPRAYING

THIN ACRYLIC PAINT CAN also be sprayed from an airbrush or spray-gun. The mixture can be as transparent or opaque as you like. The dilution can be as great as 50/50 water to acrylic or as little as 25% water to 75% paint. The addition of either gloss or matt medium is recommended to ensure maximum adhesion of the paint. Spraying can be carried out on any kind of surface as recommended in Chapter 1. Spray-guns are delicate instruments and the makers' directions regarding the application of the paint and cleaning should be followed scrupulously.

The results of spraying can vary from gently gradated tones to more brilliant effects. Spraying is a flexible way of creating realistic and decorative effects, and to carry it out numerous masks and stencils are needed. One way to protect parts of the work from undue spraying is to apply masking tape to them.

TAPING

THE USE OF MASKING tape to protect parts of the work not to be damaged or painted accidentally has given rise to a number of techniques which can be used for certain kinds of painting.

For example, if the work is to be very flat, and very precise in its form, masking tape placed at the edges of the area to be painted, will protect that edge, and ensure that a good flat paint can be produced without the fear of going over the edges. The masking tape will give a good hard edge to the areas of paint.

The paint can be brushed over the masking tape with complete confidence. When the paint is thoroughly dry, the masking tape can be removed leaving behind a crisp, flatly painted area with hard edges.

However, it is advisable to make sure that the masking tape is carefully stuck down, and that there are no bubbles in it. Also the density of the paint should not be too thin. For the best results, the paint should be really opaque, if necessary applied in a thick layer. The addition of a matt or gloss medium or water tension breaker (wetting agent) will ensure that the paint flows well.

SPRAYING

ABOVE Use the spray-gun with masking fluid to create a pattern.

ABOVE When the masking fluid has dried, spray a layer of paint over it.

MASKING

ABOVE Masking tape is placed across the support in the appropriate place. The artist

works with colour from the tube, spreading it across the tape with a small brush.

ABOVE The artist continues to spread the paint, working

away from the masked area.

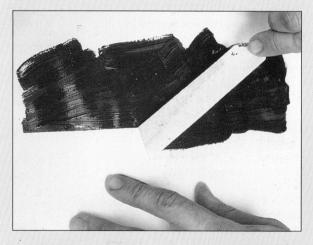

ABOVE When the paint is dry, the tape is removed. The underlying support has been

protected and a hard line of paint produced.

MURAL PAINTING

IN ALL MY EXPERIENCE as a mural designer, I have found acrylic to be the best all-round paint for painting on walls. Wall painting is at best an arduous task which can be made unnecessarily difficult if the paint used is unsympathetic to work with.

Problems with murals arise because you never know how the walls will be deployed from site to site. Sometimes they can be ideal – the right height, good light, easy access, plenty of room to work in. In such circumstances the problems of the paint are not so imperative.

But very often the walls will be high, the light poor or changeable, and so work has to be carried out on steps or scaffolding, which means that the mixing table might be elsewhere, and the paint carried to the wall for application. If the mix is wrong, the whole operation has to be repeated: mixing in one place, and painting in another, which can be very tedious to say the least. I find acrylic easy to mix, store and transport up and down ladders, and it is easily brushed on to the wall, and you know that the paint film is tough enough to withstand the wear and tear a wall painting has to endure.

When I used acrylic for the first time on a mural, I devised a completely new method to deal with it. First the walls were primed with acrylic primer, which was a delightful surface to draw on, and when completed the drawing was covered over with a semi-transparent wash of pale ochre, umber and white.

The intention was to create a neutral tone over the whole work so that the lighter and the darker tones would relate properly with each other.

When the underpainting was dry the major areas of the mural were filled in carefully, including some of the detail. Because of the neutral tone covering the whole work, this could be done with confidence, whereas if it had been attempted on a white ground all kinds of problems would have ensued.

The method adopted here was to become the foundation of the whited-out method discussed earlier. Though it wasn't used in this instance, it was used in later works of this kind.

As will be seen in the colour reproduction, the colours are rich and bright, the detail sharp and clear. This could not have been achieved so successfully with other paints, as they do not possess the quick-drying properties and translucency of acrylic, therefore the overpainting method cannot work as well.

As will be observed in the almost completed wall, large areas of the underpainting have been left untouched, and remain as they were originally painted with the free brushwork contrasting with the clear-cut shapes of the design.

Acrylic is ideally suited to murals and wall decoration, not only as paint, but as a means of creating textures, and surface variation so that the light can play its part as well. For those unused to painting on a wall, who would like to try some of the methods suggested in this section, if the work cannot be carried out directly on the wall, it can be done on sheets of card (cardboard) or hardboard first, and

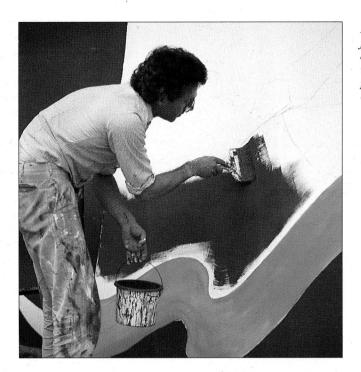

Acrylic is one of the best paints for mural painting. Here, the artist paints part of a mural. He is working on one of seven separate panels. Once all the panels are completed, they can be positioned.

placed into position afterwards. This means that if the work is not immediately successful, it can be removed easily, and a new section put in its place.

Of course, the real satisfaction of mural painting is to paint or work *in situ*, but working on removable panels is a good introduction to seeing if the design is effective without harm to the wall.

DRAWING AND ILLUSTRATION

THOUGH DRAWINGS AND ILLUSTRATIONS can be adequately carried out in most other mediums, acrylic offers tremendous scope for the further exploration of tones, shapes, textures and colour, which would be of inestimable value in both areas.

Black and white drawings can be enhanced by the addition of washes of transparent or semi-opaque acrylic colour, provided a few conditions are observed. Charcoal, charcoal pencils, conté crayon, carbon pencils, chalks and pastels will tend either to run or be picked up by any washes or overpainting, and unless this particular quality is especially needed, it is advisable to fix the drawing first. The ordinary type of fixative is not recommended as it might impair the adhesive qualities of the acrylic, therefore some acrylic gloss or acrylic matt medium can be sprayed with safety over the drawing with a spray diffuser and will hold the drawing in place.

Alternatively the drawing can begin with washes and then be drawn over with pen, charcoal pencil, crayon and so on. Ordinary pencils smudge less and pick up less than carbon pencils and can be painted over quite easily.

Pure charcoal, however, is prone to smudging and picking up as it does not contain any binder whatsoever. And though most other drawing mediums contain a little binder, it is safer to fix them as a precaution.

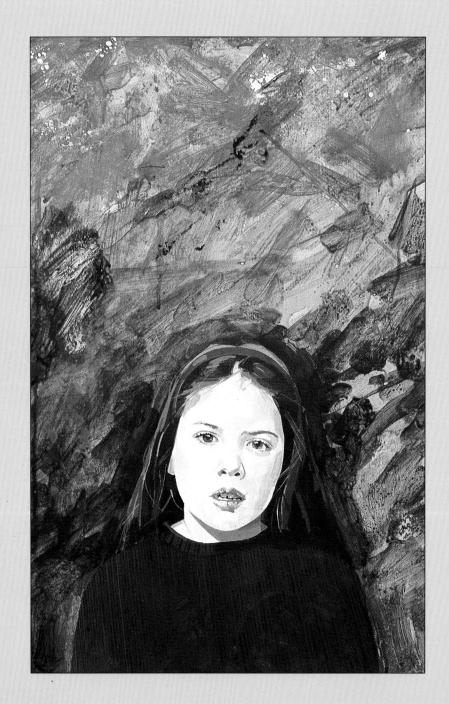

Melissa

EPILOGUE

CRYLIC – as I hope I have amply demonstrated – is a wonderful paint, in fact, a magic paint that can do everything other paints can do, and in many instances far better – more transparent than watercolour, more opaque than gouache, and thicker than oil paint. It dries quicker, is more resilient to damage, and more versatile than any known paint today.

TO MAKE ACRYLIC PRODUCE WONDERS is not the province of the manufacturers, but of the user. The magic, alas, won't happen by itself.

Technique will enable acrylic to go some of the way to fulfil its potential, but the magic needs imagination. Whereas oil paint demands years of discipline to allow any magic to come through, acrylic can accommodate lots of imagination to let it happen sooner. You can experiment with acrylic in a way that would seem presumptuous with other mediums. There are no rules you break at your peril, only a few simple conditions that should be observed, to get the magic working. They can be summarized thus: Use plenty of clean water. Keep brushes clean by washing immediately after use. Mix the paint well. Don't be cautious about adding extra acrylic medium to mixtures; additional medium always makes paint flow better. To produce the maximum visual qualities of acrylic in a subtle and arresting way, let the painting show on its surface the effect of the layers beneath. Vary the layers and allow each one to show through. Starting with lean paint, and finishing with thick is better than starting with thick paint, because once acrylic is dry it is almost impossible to remove. Allow washes to show the white surface through the transparent layers. Unlike glazes which can cover any surface or underpainting, both thick and thin, washes depend on the white surface to give the sparkle needed When in doubt white it out. Enjoy the process.

Whoever said, 'Paints were invented solely for enjoyment...' made a good point. They undoubtedly are, and acrylic paints even more so. But to enjoy them fully a number of conditions have to be considered. Some are familiar; others might be somewhat strange. But they are all relevant, as much to the amateur, as to the professional.

Briefly they are: Liking what we do, rather than doing what we like. Accepting that means are more important than ends. Letting the ends take care of themselves. It is the process that matters. An attitude of optimism. Aim to be natural, and not to strive too hard. Cultivate patience. Allow progress to develop at its own pace. Decide and act. Practice constantly.

Liking what we do means accepting our own efforts as valid – even if they don't come up to our own expectations – because they are our own and not somebody elses's. Of course it is natural to admire the achievements of others, and wish to do likewise, but this kind of ambition will only lead to disappointment. Equally we may like to impress others with what we do, and because it fails to excite the admiration we would like, we will tend to

PAGE 112 This portrait of a young girl was painted on primed hardboard using as reference a colour photograph blown up to life size.

RIGHT David Hockney, Mr and Mrs Clark and Percy. The artist achieved the fine translucent finish of the vase and flowers and general even tone by using paint in a carefully controlled manner.

Lanyon Quoit

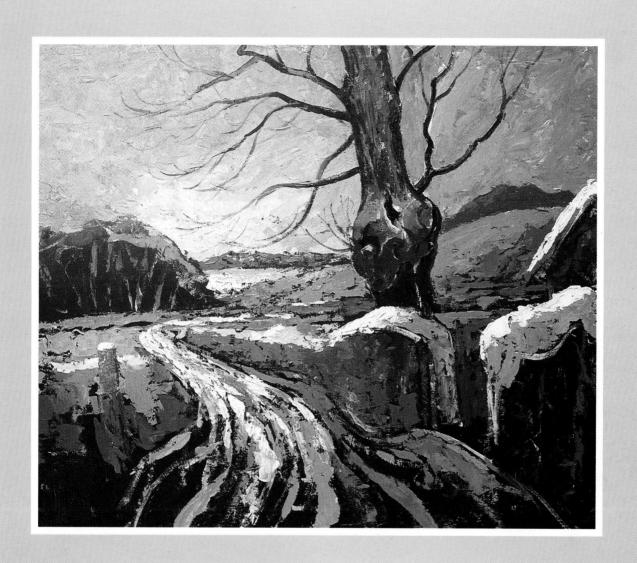

Wintry Landscape

Bottle, Fruits and Vegetables

become discouraged. And when this happens, enjoyment flies quickly out of the window. The ends we choose will have a direct bearing on the way we enjoy our work – hence means being more important than ends. If we enjoy the means the ends will take care of themselves.

This is not to say that ends are not without value and that aims, ambitions or intentions are unnecessary. Far from it. In their proper context, they can be the motive or spur for what is to be done; moreover they can provide the excitement that goes towards the creating of significant work. But for the successful realization of these goals, each stage of the process must be given due attention and not be rushed or skimped (hence the need for patience), or despaired over (hence the need for optimism).

Whatever the personal target, working towards it should be enjoyable. For if we enjoy what we do, the enjoyment becomes part of the work and will be seen and enjoyed by others in turn. What we should realize is that our work is like an open book, available for all to dip into and read. What we put into it, someone else can take out.

Painting and designing are processes that need constant practice. This is the secret: only practice will encourage skills to grow, understanding to ripen, and allow work to develop and, above all, for enjoyment to increase.

Practice *is* everything. It is the centre of an artist's working life and, consequently, looked forward to, if only for an hour a day.

Of course 'mistakes' will be made, but they should be seen as part of the process. Making errors of judgement is the only way to develop, make us more critically aware, and so build up confidence in what we are doing.

If making mistakes is a persistent worry remember that 'those who never make mistakes, never make anything . . .' and take heart.

The methods that I have described in this book take all this into consideration. The suggested painting exercises and experiences will do a great deal to forestall many of the major difficulties that may occur when using acrylic for the first time. This is because the exercises bring into play natural abilities. There is no need to learn any special way of doing things as one would when learning a performing art. These exercises can and should be adapted to suit the individual personality of the user. They can be played by the book or turned upside down if need be, without harm. The information is there to be used, and how it is done is a personal matter, whether you are an amateur dabbler or an aspiring professional.

Expertise should be acquired slowly on your own terms. The principle to follow is to do things gradually and deliberately at your own pace, in your own way.

If I were asked to sum up this book in one word, it would be action. Painting is an immediate activity that takes place only in the present. In short, it happens now. To enable this to happen, the best procedure to adopt is to decide and act. The secret is to make up your mind as clearly and firmly as possible and then, without any hesitation, act. For whatever is decided – and this is the point – will be correct. The success of the outcome depends not on what is decided, but on the act of decision itself.

PAGE 116 An understated composition, subdued colours and restricted tonal contrast are masterfully combined in this painting to create this sombre and overcast scene.

PACE 117 An advantage with acrylic is that light colours can be laid on top of dark. Here, the warm, dark undertones provide a contrasting base to the cold, light tones of the snow and sky.

LEFT Acrylics were chosen for this still life because of the bold colour scheme of the subject. The aim of the artist was to create a composition using the classical triangle, with the bottle as the focal point.

ABOVE This composition deliberately contrasts hot and cold colours. The use of complementary colours is heightened by small touches of shadow.

RIGHT This micro-landscape, painted out of doors from life, has no formal composition or focal point. The use of thin paint on a good quality stretched paper produced the watercolour effect.

PAGE 122 The furrows in this ploughed field were painted using the wet-in-wet technique. This avoids a hard line and achieves instead, a soft, blurred image.

PAGE 123 What makes this painting interesting is the artist's use of graphic technique to produce bold lines, and his creation of different textures.

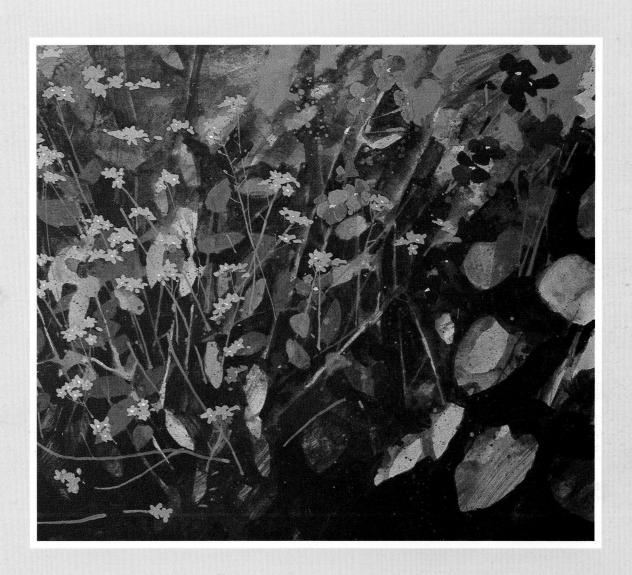

Wallflowers and forget-me-nots

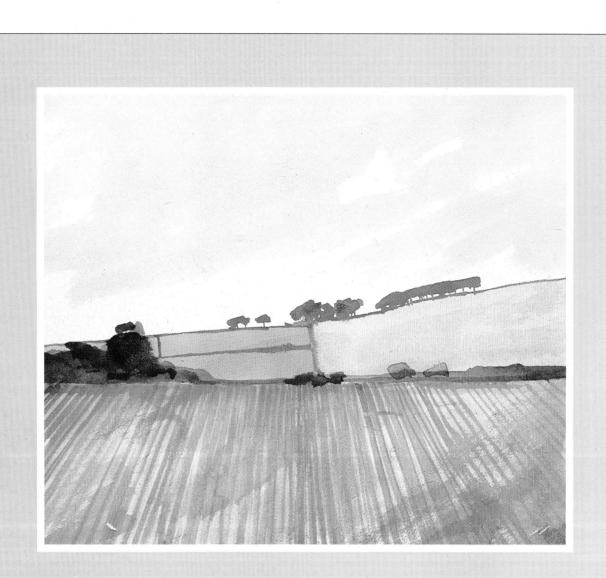

Ploughed fields

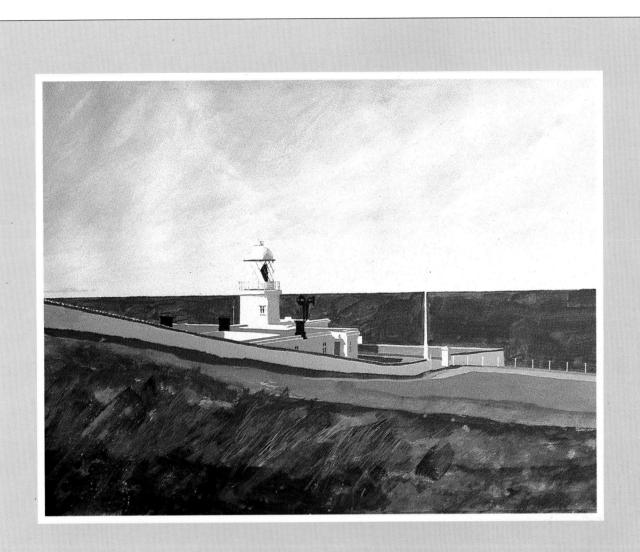

The Lighthouse

GLOSSARY

Action painting. Splashing and dribbling paint on canvas. The technique is supposed to be derived from Leonardo's suggestion of using stains on walls as a starting point for a design.

Alla prima. Completing the painting in one session with

neither underdrawing nor underpainting.

Binder. The adhesive that holds the powdered pigment together. See Medium.

- Blocking in. A technique which is very often used by painters working in acrylics. Blocking-in is the process of putting down roughly the main areas of tone and colour in a composition before the work begins.
- Bottega. The workshop or studio of an artist, specifically where the pupils and assistants worked on commissioned production, from and usually signed by the master.
- Brushwork. The personal handwriting of a painter. May be thick or thin, gentle or vigorous depending on the form of expression of the artist. It may be aesthetically pleasing in itself.
- Chiaroscuro. Literally 'light-dark'. The balance of light and shadow. The way nature can be represented by its use.
- Collage. To stick. A picture or design built up from pieces of coloured paper. Devised by the Cubists. Any materials may be used likewise.
- Complementary colour. Each primary colour red, yellow, blue has a complementary formed by the mixture of the other two.
- Composition. The art of combining the visual elements for a picture into a satisfactory whole.
- Design. Roughly has the same meaning as composition, but applies also to artefacts and decorative objects, and functional equipment. Also has the same meaning as the Italian word *disegno* to mean drawing.
- Diluents. Liquids which dissolve and mix with oils, resins and other paints to thin them and reduce viscosity so that they may be more easily applied. Also referred to as 'thinners' or solvents.
- Disegno. An Italian word capable of many meanings, the simplest of which is drawing and the next simplest, design.
- Drawing. The simplest way to plot out an image;

to organize shapes and tones preparatory to painting or designing. To put down what is seen in an ordered way so that it is immediately understood. The way artists and designers think about their work. The artists' way of making notes and observations for future reference.

Distemper. Powdered colour mixed with glue size. Because of its relative simplicity and cheapness was often used as a household paint for decoration, but since superseded by acrylic paints. Not to be confused with tempera.

Fixative. A kind of thin varnish sprayed on to drawings and pastels to prevent their being rubbed (or picked up if

overpainted).

- Fresco. Wall painting with a medium like watercolour (but without any binder) painted on to wet plaster which when dry acts as the binder by 'locking-in' the paint. Absolutely permanent when favoured by a dry and warm climate.
- *Gesso.* Name of the ground used for tempera painting, and sometimes oil. Not recommended for acrylic.
- Glazing. The process of applying a transparent layer of paint over a solid one so that the colour of the first is blended or modified by the second. With acrylic, any number of glazes may be applied, whether over solid or transparent colour.
- Gouache. Opaque watercolour known variously as poster or designer's colour. Often used as a substitute for oil paint, but lacks the sparkle of acrylic to do it well.
- Graphite. Substance which, when combined with a form of fine clay, makes the 'lead' for pencils.
- *Handling*. The name given to the most personal part of the work the actual execution.
- Hatching. Gradating tones by parallel lines. Cross-hatching by two or more parallel lines. But in practice, hatching refers to any kind of small lines or strokes criss-crossing to create a tonal effect both in black and white and colour.
- *Hot colour.* Colour which tends to be reddish in hue. The red end of the spectrum. Similarly, cool colours would tend to be blue, or at the blue end of the spectrum.
- Impasto. The application, by knife or brush, of thick layers of paint to the support, using colours at tube consistency.

- *Key.* Colour is said to be high or low in key according to whether nearest to white (high key) or black (low key).
- Marouflage. Process of affixing canvas to a wall by means of cement. Can also mean glueing canvas to a support.
- Masking. The technique of covering areas of the support (with either masking fluid or tape) in order to create a hard edge to the area being painted. The artist is free to use loose brushstrokes, while at the same time protecting the covered area.
- *Medium.* 1) The liquid constituent of a paint in which the pigment is suspended. 2) Liquid with which the paint may be diluted without decreasing its adhesive, binding or film-forming properties. 3) The mode of expression employed by an artist, i.e. painting, sculpture or etching. 4) The actual instrument used by an artist: acrylic or oil paint, chisel, needle etc.
- Mixed method. Originally oil glazes over a tempera under-painting, but can also mean mixing compatible mediums like collage and paint; painting over drawing with inks, acrylic, and vice versa; adding three dimensional objects to a flat surface etc.
- Mural or wall painting is a term to describe any kind of wall decoration. Not interchangeable with fresco.
- Paint quality. One of the desirable visual attributes of a finished painting. The term does not refer to good or bad ingredients. Paint quality is intrinsic for material beauty or successful surface effect. Something that comes with skilful handling, but often helped by the paint concerned like acrylic, which has a sympathetic paint quality.
- Palette. The implement on which a painter mixes his colours, but can also refer to a selective assortment or group of colours, chosen for use in painting technique. Most artists' selection of colours is referred to as their palette, and invariably differs from other artists' palettes.
- Picking-up. What happens when a colour is laid over another incorrectly, so that the two colours combine and become muddy.
- Pigment. The substance that gives materials their colour when mixed with a binder. Pigments are either organic (earth colours) or inorganic (those made from minerals or

- chemicals).
- Primary colours. The colours red, yellow and blue, which combine to form the complementary colours.
- Retarder. An additive to delay the drying process of acrylic paint.
- Sable. Small rodent-like animal, the fur of which goes to make fine, high-quality (and often expensive) brushes.
- Scumbling. The opposite of glazing. Working an opaque layer of paint over another of a different colour and allowing it to show through, giving a broken, uneven effect.
- Size. Used as both a noun and a verb. Size is the solution that is used to coat a support in order to render it less absorbent. To size is to carry out this process.
- Stippling. The building up of tone with hundreds of tiny marks made with the point of the brush.
- Support. The surface to be painted, i.e. canvas, card (cardboard), paper, wood, hardboard etc.
- Tempera. Any kind of binder that will serve to temper powered pigment and make it workable. In practice the term is usually confined to egg tempera only, yolk of egg being the binder. A unique but very slow medium to master.
- Tooth. A slight roughness or coarseness in the surface of a dried paint film or painting ground which assists in the application and bonding of a subsequent coat of paint.
- Underpainting. Preliminary lay-in of a work by drawing, to assess the composition and tone values before the application of colour. Can also mean the preparation for a glaze, and be the basis of a scumble.
- Vehicle. A liquid used as the carrier of pigments in a paint. The term is interchangeable with medium, but is perhaps more properly applied to the liquid used as an ingredient in manufacture than to a liquid added during painting procedure.
- Wash. An application of paint that has been heavily diluted with water, in order to make it flow freely and thinly, and to give a translucent effect.
- Whiting-out or repriming is the process of covering a painting or part of a painting that has 'gone wrong' with a semitransparent layer of white or tinted paint.

INDEX

Page numbers in italics refer to captions and illustrations.

AAAAAAAAAAAAAAA

accessories 32, 33 adhesive tool, impasto work with 43 airbrush 109 animal paintings 88–9, 89, 90–2, 92, 93–5, 95 artist's donkey 33

backgrounds: acrylic under oil 21 establishing in colour exercise 39 overlaying 98 binders 14, 16, 17 weakened in glazes 44 see also emulsions; gum; mediums (acrylic); oil bird paintings 96–8, 98 black paint 37, 39 mixing with colours see tones see also greys exercise using 39-40 Boats on the Beach 72-4, 74 Bottle, Fruits and Vegetables 118, 119 Braque, Georges 106, 107 brushes 26, 26, 27, 27, 32 care/cleaning 28, 29, 29, 32, 114 equipment for 24 hard see hog's-hair brushes holding 28 impasto work with 41, 41, 42 marking/manipulation exercise mixing with 25 for priming supports 27 removing dry paint from 21 size range 28 soft see sable brushes synthetic see nylon brushes technique in colour exercise 39 using old/worn out 45, 45 hatching with 50 stippling with 51, 51 for varnishing 20 for washes 48 wetting before use 36-7 see also household brushes brushstrokes 56, 103 animated 49, 49 broad/loose 94 direction of 76 in impasto work 42, 42 with sable brushes 27 in scumbling 44 see also hatching

ccccccccccccccc

calico, unbleached 31 canvas 14, 28, 29, 31 disadvantages 31 glued on hardboard 32 priming 30 stretching 30, 32 using texture of 56 wash experiments on 48-9 canvas board 28 canvases 31, 31 avoiding creases/dents in 31 tightening 31, 32 see also stretchers unusual shapes 32

card (cardboard) 9, 14, 28-9 exercises: glazes on 43, 44 experimenting on 48-9, 110-11 mounting 40 palette 25 priming 30 number of coats 31 suitability 31 texturing 107 simulated grain 29 casein glue, as binder 17 cellulose filler 107 ceramic, unglazed 40 chalks, fixing 111 character, capturing 90, 93, 102 charcoal, fixing 111 Chimpanzee 90–2, 92 china 25 removing dry paint from 20 cloth, types to use 9 see also calico; canvas; hessian; linen; silk clothing, removing dry paint from 21 collage 106-7, 106 medium for 19 colour chart 37 colour circle: exercise 40 ready-made colour schemes 40 response to groupings 40 colour temperature 37, 37, 120 colour theory 37 colours 22 bright/brilliant (high-key) 14, 16 binders and 14 varnish and 19, 20 broken effects see scumbling choosing 37 dark to light 78, 79 effect of glazes on 43 effect of hatching on 50 effect of mixing with palette knife 25 effect of mixing surface on 25 effect of primary on secondary effect of stippling 51 essential/necessary 37 see also primary colours exercises 37, 38–9 fading 16 gloss medium and 17 increasing wetting/penetration see water tension breaker light on dark 75, 84, 86, 89 limited palette 64, 65 mixing exercises 37 direct vision 39 light to dark 38-9 mixing: brid 38 see also tints; tones naming 16 natural/artificial 16 permanence: binders and 14 overlay technique 49, 49 range 10, 14 removing from brushes 28 sensitivity to 39 sombre 14 study of 36 success on murals 110 transparency: gloss medium and warm/cold see colour temperature

see also black paint;

complementary colours; earth colours; primary colours; secondary colours; tints; tones; white paint comb 107 complementary colours 40, 40, 120 contrast exercise 40 with intermediate tints/tones charts 40 use of 40 Constable, John 14 conté crayon, fixing 111 Cooper, Sarah 24 copal 17 Cornfield in Summer, A 75-6, 76 cropping 99, 100 Cubists 107

DDDDDDDDDDDDDDD

daler board 28

Degas, Edgar 37

dammar 17

design/designing 106 practising 119 detail, 'editing out' 75, 87 diluents (solvents): binders and 14 brush cleaning with 28 in paint preparation 21 see also water dragging see scumbling drawing: acrylic combined with 36 on acrylic primer 110 enhancing black-and-white 36, fixing 111 function of 106 see also key drawing; outline drawing drawing pins (tacks) 32 'dry paint' technique 45, 45 acrylic qualities of 9 amount of water and 36 binders and 14 glazes and 62 slowing for varnish 20

speeding up 17

see also retarders

EEEEEEEEEEEEEEEEEEE easels 32, 33 for outdoor work 32 earth colours 16 amount of retarder for 21 grounds in 72 see also sienna; umber egg yolk 17 equipment 10-11, 21ff essential 32, 33, 36 see also individual items exercises: brushes: marking manipulation 28 technique in colour 39 colour 37, 39 complementary contrast 40, palettes for 37 primaries 39-40 secondary 40 colour circle 40 colour mixing 37 direct vision 39 greys 38-9 light to dark 38-9

same observed colour 39

glaze, on card/paper 43, 44 painting 119 using blue/red paint 39-40 scumbling 45 washes 38 on card/paper 48-9 exhibition stands, varnishing for 19-20 experiments with acrylic 11, 24, 106, 114 on card 110-11 on hardboard 110-11 hatching 51 texture 107-8, 108 in murals 110-11 washes 47-8 adding colour (wet-in-wet) animated brushstrokes 49, 49 on canvas 48-9 flat wash 48 gradated tones 48, 48 overlay 49, 49

FFFFFFFFFFFFFFFFFF

fabric, dyed 40 fingertips 51 fixative 111 Food on the Farm 60-1, 61 format, choosing 90 fresco 17 hatching in 50Fruit Trees 83-5, 85

gel medium 18, 18, 19

GGGGGGGGGGGG

as glaze 44 effect on colours 18 in impasto 41, 41, 42 mixing 19, 42 and paint consistency 36 gesso 18, 36 supports for 29 glass: as palette 25 removing dry paint from 20 as support 30 glazes/glazing 18, 36, 43, 43, 45, 75, 78, 86 applying 86 exercise in 44 gel/gloss medium and 17 impasto with 42 mixing 43 over underpainting 62, 62–3 permutations 44 transparent 43, 43 gloss medium 17-18, 18 as fixative 111 and glazes 17, 18 priming with 31 in spray paint 109 water tension breaker and 19 gloss varnish 9, 18, 19 satin/eggshell finish 20 gloss varnish remover 20-1 glue: acrylic as 10 for primings 29 glue size 36 gouache 16-17 acrylic combined with 36 binder for 16 diluent for 14 gloss medium added to 17-18 hatching with 50 repriming with 45 graphic technique 120

greys 40 background/underpainting of 41 coloured 41 mixing 39 mixing exercise 38-9 see also 'optical grey' ground/priming 28, 29 broken 41 mid-tone on white 41 plaster-based see gesso ready-made 14 toned 72 applying 72-3 traditional colour 29 Grumbacher 18 gum 16-17 arabic 16 tragacanth 16

HHHHHHHHHHHHH

hardboard 9, 14, 28, 28-9, 31, 32, battened/framed 30, 32 checking 30 experimenting on 110-11 oil/acrylic paint on 21 palette 25 priming 30, 31 simulated grain 29 hard-edge techniques, water breakers and 19 hatching 10, 50, 50 experiment in 51 hessian 31 Hockney, David: Mr and Mrs Clark and Percy 114 hog's-hair brushes 27 for washes 48, 49, 49 household brushes 27 priming with 30

ининининининини

illustration 111 impasto 18, 36, 41, 60–1, 75 applying 41, 42, 60–1 textural ideas 43 easel for 32 gel medium and 18 mixing 41 repriming and 47 texture paste and 18 varnishing 20 vitality of 42 Impressionists, the 14 inks, combined with acrylic 36 interiors 64, 64-5, 106 Irises in a Green Vase 66-9, 69

KKKKKKKKKKKKKKKK

key drawing 73 kitchen fork 43 kitchen paper towels 32

landscape 70-1, 71, 75-7, 76, 117, 119 and colour theory 37 micro- 120 river scene 86-7, 87 urban 80-2, 82 washes and 49 Landscape with Shed 70-1, 71 Lanner Falcon 96–8, 98 Lanyon Quoit 116, 119 Lighthouse 78-9, 79

Lighthouse, The 120, 123 lighting: controlling in interior 64 from one side 66 lime 17 see also gesso linen 31, 40 ready-primed 31 linseed oil 17

MMMMMMMMMMMM marble tops 25 masking/masking tape 92, 109, 110 see also stencils masking fluid 109 mastic 17 Matisse, Henri 107 matt medium 18, 18 adding to stains 109 as fixative 111 priming with 31 in scumble mix 44 in spray paint 109 water tension breaker in 19 matt varnish 9, 18, 19-20 satin/eggshell finish 20 matt varnish remover 20-1 medium (acrylic) 17, 36 additional amounts to use 114 collage with 106 diluting 19 glazing with 44 effect on glazes 44 on unprimed canvas 32 in washes 48 Melissa 112, 114 metal: palettes 25, 40 as support 30 Millington, Terence: Sofa 8 mixed media 46 textural variety and 59 models: brushes for painting 27 texture experiments 107 mood, creating 64 Morris, William 14 mural painting 110-11, 111 surface finish for 30 varnishing 19-20

инининининини

nudes, and colour theory 37 nylon brushes 27-8

00000000000000

ochres 16 amount of retarder for yellow 21 mixing 37 red as broken ground 41 oils 17 oil crayons, with acrylics 21 oil paint: acrylic paint under 21, 66, 68 base for 29 brushes for 27 canvas shapes 32 cracking 62 diluent for 14 disadvantages 17 gradating tone with 50 preparing canvases for 29 repriming with 45 oil painting: base for 29 canvas shapes for 32 'optical grey' 41

outline drawing: charcoal 93

paint 62, 83 pencil 65, 71, 81, 88, 90 transferring to canvas 96 overlay 49 overpainting: oil over acrylic 21 toned ground with 72 washes and 49 ox-hair brushes 27

see also painting; watercolour

painting: alla prima 63, 84, 94

essential requirements 32

influence on design 106

basic function 106

infrastructure 36

practising 96, 119

exercises 119

'negative' 65

painting knives 26, 26 applying glaze with 44 impasto work with 42, 43 repriming with 47 substitute for see razor blades texturing surface with 60, 60 painting table 25 paintings: correcting see 'whitingout' preparing for varnishing/ revarnishing 20 removing dry paint from 21 reusing old 60, 60 paints (acrylic) 28, 114, 119 advantages 78 buying 10 characteristics 9-10, 18 cleaning tube necks 32-3 consistency 36 diluting 19, 46-7, 86 overthinning 47 for spraying 109 experimenting with 11, 106, 114 exploiting qualities 24, 114 making 14 base for 29 components 36 light on dark 119 mixing 114 containers for 25 keeping ready-mixed 37 equipment for 25 for impasto 41, 41, 42 oil techniques with 70 over masking tape 109, 110 over oil paint 21 preparing 21 qualities 8 removing dried 20-1, 28 'sculpting' 60 see also impasto study of layers of 36 uses 106ff. see also 'dry paint' technique; pigments; individual types palette knives 25-6, 26, 32 cleaning 25, 32 impasto work with 41, 41, 42 mixing with 19, 25, 28 impasto 42 retarders/paint 21 painting with 26 priming with 30 wetting before use 37 see also painting knives palettes 24, 25, 32 cleaning 25, 32

equipment for 24 for colour exercises 37 ideal 24 removing dry paint from 21 surfaces 25 paper 9, 14, 28, 40 glaze exercises on 43, 44 wash experiments on 48-9 pastel 40 priming 30 primed 28 suitability 31 for stippling 51 stretched 70 acrylic on 120 palettes 25 parchment size, as binder 17 pastels 16 acrylic with 59 binder for 16 fixing 111 fragility of 16 pencil: adding texture with 68 fixing 111 gradating tone with see hatching Phillips, Tom: Benches 10 photographs 83 using as reference 54, 54, 93, 93 Picasso, Pablo 106, 107 pigments 14, 16 addition of white to 16 see also gouache effect of oil on 17 raw materials 16 plastic 9, 40 as support 30 palettes 25 Ploughed Fields 120, 122 plywood 28 portraits: and colour theory 37 three-quarter 102-3, 103 see also self-portrait poster colour 17 posters: 106 varnishing 19 primary colours: balanced 37 with contrasting complementaries 40 see also blue; red; yellow primer 18, 36 applying 30 function of 36 for palettes 25 white acrylic 30, 30, 36, 110 with texture paste 107 priming 30-1 over acrylic medium 32 ready-made canvases 31 repriming see 'whiting-out' stretched/unstretched canvas 32 wall surfaces 110 see also ground/priming printer's mixing knives 26 prints, varnishing 19 putty knives 26

radial easel 32, 32 rags, clean 32 razor blades 32 red 37 amount of retarder for light 21 exercise using 39-40 research, importance of 106 retarders/retarding medium 18, 21 in paint preparation 21

revarnishing 20 roller (paint), priming with 30 Rosoman, Leonard: *Girl Lying in a Hammock 8* mural, detail *8* Rowney Cryla *18* Rowney Flow Formula *18* Rowney soluble gloss *18*

555555555555555555

sable brushes 26, 27 cleaning 27 hatching with 51 for washes 48 sand/grit, with texture paste 83, sawdust, with texture paste 18, 107 scratching 45, 107 sculpture, brushes for painting 27 scumble/scumbling 36, 44, 44-5, 70, 71 exercise in 45 mixing transparent 44 techniques 44, 45 dry brush 45 on toned ground 72 sealers 36 seascape 78-9, 79 secondary colours 37 exercise with 40 Self-portrait 99-101, 101 Seurat, Georges 51 shadow, framing with 85 siccatives see copal; dammar; masatic siennas: amount of retarder for 21 mixing 37 silk 30 sizing 31 sketchbooks 83, 88 sketches: preliminary/preparatory 73, 75, 75, 90, 90 reference 83, 83, 93 with paints 58-9 solvents see diluents (solvents) spike/needle 32 sponges: for clearing up 32 for stippling 51 spray-gun 109 using 109 water tension breaker in 19 squirrel brushes 27 stains/staining 108-9 applying to support 109 as broken ground 41 in texture paste 107 water tension breaker and 19 stainless steel, removing dry paint from 20 stencils 66, 67, 68, 103 spraying through 109 Still Life with Bottle, Fruits and Vegetables 62-3, 63 still lifes 60–1, 61, 62–3, 63, 66–9, 69, 118, 119 and colour theory 37 grounds for 41 stippling 10, 51, 51 materials for 51 stretchers: fixed 31-2 ready-to-be-assembled 14 assembling 30 warping 31 wedged 31–2

studies, pencil 93 studio work, easels for 32, 32 Suffolk Punch 88-9, 89 supports 14, 28ff., 32, 36 for acrylics 9, 30ff. best for 31 brushes for priming 27 coloured 40–1 home-made 14 priming 27 ready prepared 14 staining 108–9, 109 types 28 see also surfaces surfaces: coloured 40-1 suitable types 9 texture experiments 107-8 with foil 108 wash experiments 48-9 Swimmers in Hong Kong 54-7, 57

THE STREET STREET

table easel 32, 33

Thames at Richmond, The 86-7, 87 tempera 17 hatching with 50 preparing panels for 29 under oil paint 21 Tepline paste medium 19 texture 88, 120 adding 83, 83 with pencil 68 animated brushstrokes 49 of grounds see tooth effect of hatching on 50 in impasto 43 materials for giving 10, 32 and mixing with palette knife 25 in murals 110–11 repriming and 47 see also scumbling texture (modelling) paste 18-19, 20, 107–8 additives 18, 107 applying 108 direct application 20 in impasto 43 attributes 107 and paint consistency 36 in impasto 41, 43 Tiger 93–5, 95 tints: effect of glazes on 43 for grounds 41 mixing 38 effect with palette knife 25 same observed colour 39 repriming in 47 white pigment and 37 tissue paper 45 tones: coloured surfaces and 40-1 colours for producing 39 effect of glazes on 43 effect of gloss/matt medium on gradating on white paper see hatching mixing 38 effect with palette knife 25 of same observed colour 39 tonal scale 39 using 41 white/black pigment and 37 under mural 110 tooth 29, 30

on hardboard 31

on ready-made canvas 31 toothbrushes 51 trimming knife 32 Turner, J. M. W. 14

UUUUUUUUUUUUUUUUUU

umbers 16, 107 amount of retarder for 21 mixing 37 raw as neutral tint 41 undercoat see ground underpainting 36, 78 acrylic under oil 21 coloured 40 detailed 62, 62 hatching over 51 in impasto work 42 on murals 110 scumble and 45 showing through 76 stippling and 51 on stretched paper 70 warm-toned 78, 79 see also ground

VVVVVVVVVVVVVVVVVVVVVV

varnishes 36
binder and 14
cleaning 19
gloss medium as 18
siccatives as 17
see also gloss varnish; matt
varnish
varnish remover, and gloss varnish
19
varnishing 9
rules for 20
View Across the Rooftops 80–2, 82
viewpoint, choosing 90

WWWWWWWWWW

wall decorations: surface finish for varnishing 19-20 wall painting see mural painting wall surfaces 9, 28 Wallflowers and Forget-me-nots 120, 121 washes 36, 75 as broken background 41 drawing over 111 easel for 32 exercise for 38 experiments 47-8, 48, 49 flat 48 laying 47 forming acrylic 48 gradated 48 opaque paint with 88, 89 over black-and-white drawings over preparation drawing 110 over underpainting 70, 71 repriming and 47 with sable brushes 27 surface showing through 114 water tension breaker and 19 watercolour/acrylic differences wet-in-wet 48, 120 water 24, 114 adding to paint jars 39

gloss 19 importance of 36-7 lightening colours with 38 painting 54–7, 57, 78–9, 79, 86-7, 86-7 in retarders 21 rule for amounts used 36 in scumble mix 44 water containers 24, 32 water tension breakers 18, 19 adding to stains 109 effect on colours 19 in washes 48 watercolours: binder for 16 brushes for 27 controlling washes 47 diluents for 14 gloss medium added to 17-18 infrastructure 36 overthinning 47 technique 120 overlay 49 used with acrylics 70, 86-7, 87 wax, as binder 17 wax resist 46 wedges 31 placing corner 30 see also stretchers, wedged wetting agent see water tension breaker white paint 37, 39 mixing with colours see tints as primer 45, 47 see also greys
'whiting-out' 45, 47, 114
as building-up technique 47
conditions for 47 on mural painting 110 tinting 47 Windsor & Newton 16, 18 Wintery Landscape 117, 119 Woman in a Spotted Dress 102-3, wood 9, 40 collage from 107 palettes 25 panels 28 priming 30 unseasoned as support 30

and varnish 20

YYYYYYYYYYYYYYY

yellow 37 exercise using 39–40 Young Man in a Striped Shirt 58–9,

and dry paint 20

and retarders 21

and powder pigments 16

			<u>.</u>				
		.,					
	¥						
*							
				9			
				•			
	e de la companya de l					3	
X							
				, ,			
					in a state of		

•			•	
♥				
				, ,
	x y.	A		